POSTCARD HISTORY SERIES

Virginia Beach

IN VINTAGE POSTCARDS

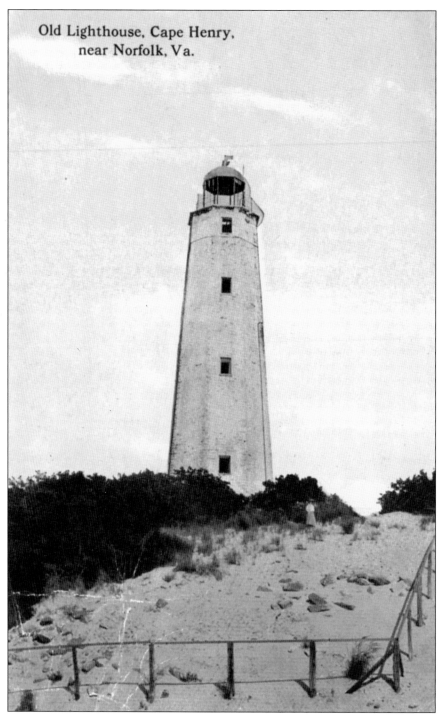

Old Lighthouse, Cape Henry,
near Norfolk, Va.

When this postcard was mailed in 1911, the "Old Lighthouse" was 119 years old. Completed in 1792 at a cost of $17,500, it was the first lighthouse built by the federal government. Although a new lighthouse was built in 1881, this one still stands proudly atop a sand dune and is considered one of the most recognizable symbols in the state.

POSTCARD HISTORY SERIES

Virginia Beach

IN VINTAGE POSTCARDS

Alpheus J. Chewning

ARCADIA
PUBLISHING

Published by Arcadia Publishing
Charleston, South Carolina

Printed in the United States of America

Library of Congress Catalog Card Number: 2004108732

For all general information contact Arcadia Publishing at:
Telephone 843-853-2070
Fax 843-853-0044
E-mail sales@arcadiapublishing.com
For customer service and orders:
Toll-Free 1-888-313-2665

Visit us on the Internet at www.arcadiapublishing.com

I dedicate this book to my wife, Carol, the joy of my life. Her love,

patience, and encouragement made this book possible.

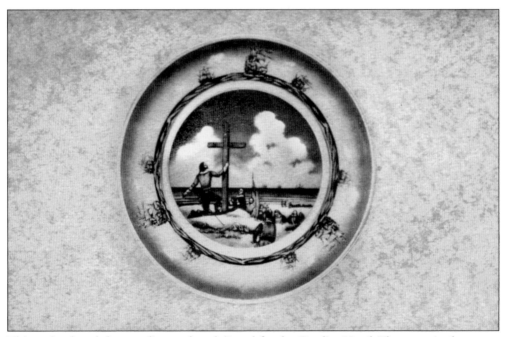

This undated card shows a dinner plate designed for the Cavalier Hotel. The scene in the center depicts "the Planting of the Cross at Cape Henry," and it is bordered by the three ships: the *Godspeed*, the *Discovery*, and the *Susan Constant*.

CONTENTS

ACKNOWLEDGMENTS

I want to thank the Virginia Beach visitors who, over the years, have sent postcards home to their families and friends. I want to thank all the "pack rats," "string savers," "collectors," and "sentimental old fools" who have kept those postcards safe in boxes, albums, closets, and attics. I also want to thank the many people who have offered up these cards for sale at flea markets, at antique malls, and on eBay. Very special thanks go to Virginia Beach natives and historians Fielding Tyler, Edgar Brown, Anne Henry, Deni Norred-Williams, Jim Jordan IV, Bill Miller, Waren Athey, and Julie Pouliot.

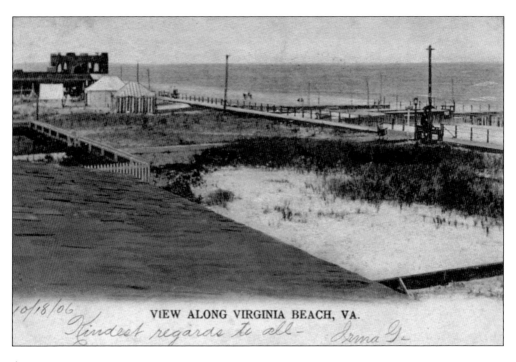

VIEW ALONG VIRGINIA BEACH, VA.

INTRODUCTION

After crossing the Atlantic Ocean, three small ships—the *Godspeed*, the *Discovery*, and the *Susan Constant*—dropped anchor in a small inlet near where Forty-ninth Street is today. While some of the sailors collected fresh water and hunted for food, others climbed to the top of the mountainous sand dunes to get their bearings. It was soon determined that this place was dangerous, inhospitable, and not suitable for the capital city of this "new world." Before moving on, however, the sailors erected a wooden cross to thank God for their safe passage. They named the barren cape Henry, in honor of King James's 13-year-old son, and the cape visible to the north Charles, after the king's other son. The great body of water between the capes was called the Bay of the Chesapeakes, after the local Native American tribe. A few weeks later, these same sailors found a small island on one of the bay's tributaries. There they established a new city called Jamestown.

In 1789, the federal government determined that a lighthouse should be built at Cape Henry. In 1792, the 72-foot tower with six sides was completed on two acres of land donated by the State of Virginia. The light remained in service without failure for 88 years, except for two years during the Civil War; when the lens was broken by Confederate troops, a lightship was used to maintain safety of vessels rounding the cape. In 1881, the old lighthouse was decommissioned and the current lighthouse went into service. That beacon still shines today, and at 165 feet, it is the tallest cast-iron lighthouse in the country.

In 1878, the U.S. Life-Saving Service built four stations along the coast in what was then known as Princess Anne County. Station #1 was at Cape Henry. Station #2 was built seven miles south, in an area known as Seatack. (The name came from a British naval bombardment, a "sea attack," in 1813.) The Seatack Life-Saving Station #2 was the first permanent building in what would become the center of Virginia Beach. Within five years, there was a railroad, a hotel, and a development company with big plans for the little resort. In 1903, the life-saving station was moved, and the current station was built in its place. In 1906, the town of Virginia Beach was established.

The growth of the city and the surrounding county continued. While the county was agricultural, the town was a very popular vacation spot. In the 1920s and 1930s, Virginia Beach was second only to New York City as an East Coast destination. The Cavalier Hotel opened in 1927 and was the largest brick structure in the state. The Cavalier, advertised in magazines around the globe as the epitome of luxury, hosted Presidents and movie stars.

In the beginning, most people came to Virginia Beach by ship. Luxury liners from New York and Baltimore docked in nearby Norfolk, and passengers caught a train into Virginia Beach. As automobile travel became more common, a ferry service brought cars across the Chesapeake Bay

from Virginia's eastern shore. When the ferry service was replaced by the Chesapeake Bay Bridge and Tunnel, lodging accommodations changed from hotels to motor courts to motels.

During World War II, this area's location at the entrance to the Chesapeake Bay made it a prominent place for battle and strategy. Sixteen-inch guns were placed at Fort Story, and the Cavalier Hotel became navy headquarters. After the war, many of the soldiers and sailors returned to make this area their home. In 1951, the Mayflower apartment building was erected and was the tallest such structure in Virginia.

In 1952, based mainly on the number of people now calling Virginia Beach their home, the little town became a city. The increased demand for houses and motels led to the unfortunate demolition of old landmark structures. The country's first geodesic dome was built as a convention center but was quickly overwhelmed by the increasing number of visitors. Virginia Beach was suffering from too much of a good thing.

In 1963, faced with a rapidly growing population and limited amount of available land, the city of Virginia Beach merged with Princess Anne County to form the city of Virginia Beach.

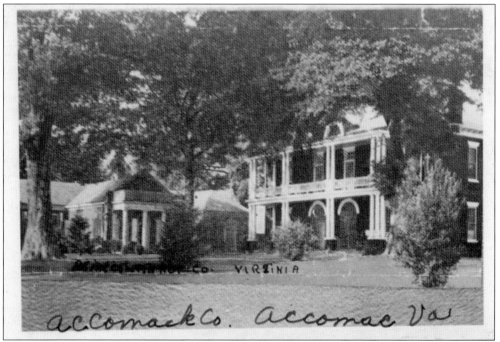

Someone incorrectly identified this image as the courthouse in Accomack [sic] County, Virginia. The card, however, is correctly labeled "Princess Anne Co., Virginia." Although the card is undated, the white columns, built in 1920, indicate that the photograph was taken after that date.

One

HOW TO GET HERE

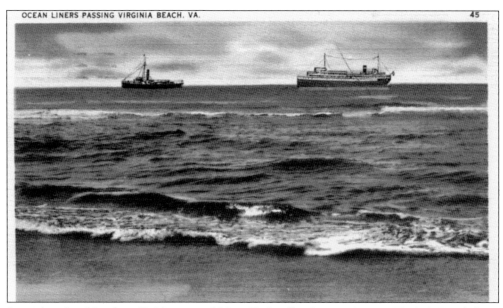

OCEAN LINERS PASSING VIRGINIA BEACH, VA. 45

Several cruise ships from Baltimore and New York offered excursions to Virginia Beach from Norfolk, the closest port of call. Although this card supposedly shows two ocean liners, the vessel to the left is actually a pilot boat escorting the bigger ship around the cape.

The Pine Woods
Virginia Beach, Va.

ON BOARD O. D. S. S. CO.'S S. S._____190

The Old Dominion Steamship Line operated six passenger liners between New York and Norfolk. These two cards were printed by the company and have a line at the bottom for the writer to fill in the name of the particular ship: the SS *Princess Anne*, the SS *Madison*, the SS *Jefferson*, the SS *Jamestown*, the SS *Hamilton*, or the SS *Tyler*. The above card is unmailed, but the card below was sent to New Jersey in 1906. Other companies that provided passenger service to the area were Merchants & Miners Transportation Company, Chesapeake Steamship Company, Baltimore Steam Packet Company (also known as Old Steam Line), and the Norfolk & Washington Steamship Company. The average round-trip fare in first class was $17.

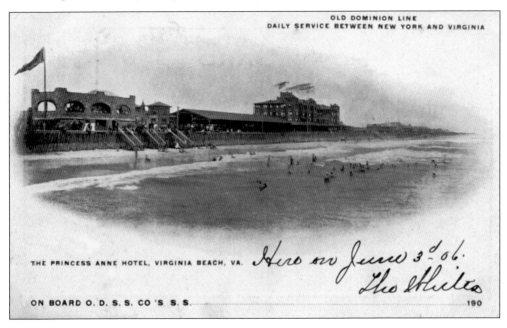

OLD DOMINION LINE
DAILY SERVICE BETWEEN NEW YORK AND VIRGINIA

THE PRINCESS ANNE HOTEL, VIRGINIA BEACH, VA.

ON BOARD O. D. S. S. CO'S S. S._____190

Before a ship enters the Chesapeake Bay, a pilot goes on board to advise the captain of the proper course to steer. The pilot is someone who is familiar with the local waterways and knows of any obstructions or shoals that might not be represented on the latest charts. On this card, sent in 1909, a young man writes to his granny, "How would you like this job? Almost as bad as a steeplejack."

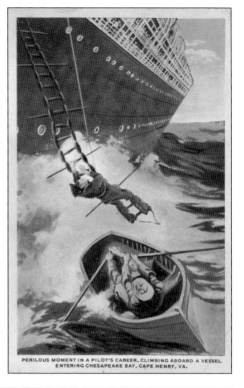

PERILOUS MOMENT IN A PILOT'S CAREER, CLIMBING ABOARD A VESSEL ENTERING CHESAPEAKE BAY, CAPE HENRY, VA.

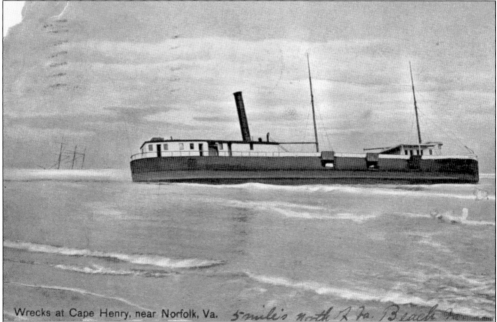

Wrecks at Cape Henry, near Norfolk, Va.

This card, postmarked 1909, shows clearly what could happen if a ship entered the Chesapeake Bay without a pilot on board. The *George M. Farwell* ran aground in October 1906 and was a complete loss. The Italian schooner *Antonio*, whose three masts are visible in the background, grounded on March 31, 1906.

14 "Green Hornet" is the Transportation in and out of Fort Story, Va.

On shore, the train served as the main transportation. Virginia Beach Boulevard, connecting Virginia Beach and Norfolk, was not built until 1921, and no bridge for automobiles spanned Lynnhaven Inlet until 1927. The railroad tracks ran from Norfolk (near where Shore Drive is today), turned south at Cape Henry, and continued on what is now Pacific Avenue. At Norfolk Avenue, the tracks turned west again, toward the city. This undated card shows a late-1930s train. Gasoline-powered trains, like this one, replaced the electric trains in 1935.

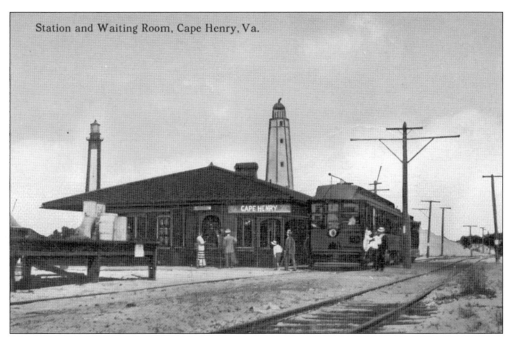

Station and Waiting Room, Cape Henry, Va.

This card shows the train station at Cape Henry around 1910. The Virginia Beach Railway began service in 1883 and, in 1900, became the Norfolk and Southern Railroad. By 1904, all the trains were electric. In 1916, 16 trains carried passengers between Norfolk and Virginia Beach each day.

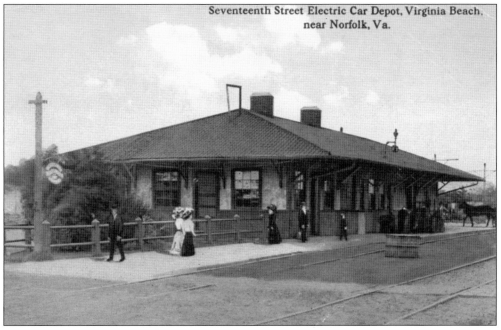

Seventeenth Street Electric Car Depot, Virginia Beach, near Norfolk, Va.

This card, sent to the Tate family in 1915, shows the electric train station at Seventeenth Street. Several stops along the route known as "the loop" included Twenty-fifth Street and one in front of the Cavalier Hotel.

In 1933, the Virginia Ferry Corporation was formed and provided automobile and passenger ferry service across the Chesapeake Bay between Kiptopeke Beach (near Cape Charles on the Eastern Shore) and Little Creek in Princess Anne County (Virginia Beach). This card, mailed in the early 1950s, shows cars lined up to catch the ferry. The crossing took 1 hour and 20 minutes.

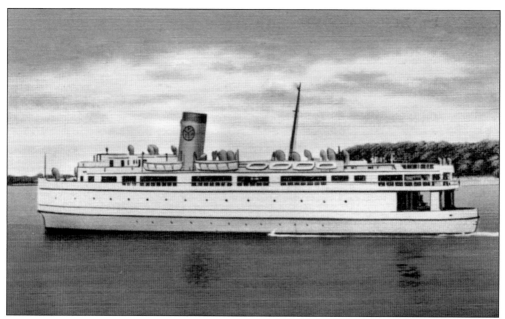

The SS Del-Mar-Va, named for the three states on the Eastern Shore, was one of the first in a fleet of several ferries that made the trip between Kiptopeke Beach and Little Creek. The cost of construction in 1933 was $600,000. The Virginia Ferry Corporation operated a 24-hour schedule and made 19 round-trips daily.

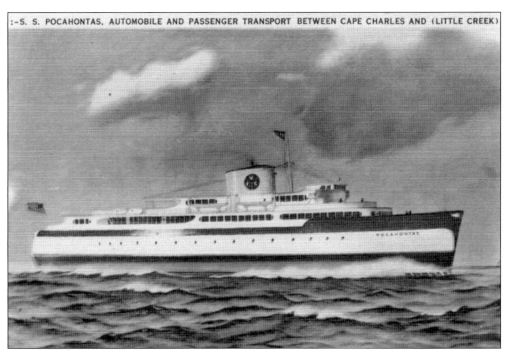

:-S. S. POCAHONTAS, AUTOMOBILE AND PASSENGER TRANSPORT BETWEEN CAPE CHARLES AND (LITTLE CREEK)

This is a card of the SS *Pocahontas*, which was built for $1.25 million in 1952. In addition to her regular duties, the ferry also made "midnight cruises" on the weekends and holidays. Built with a dining room and dance floor, the ship was perfect for these trips.

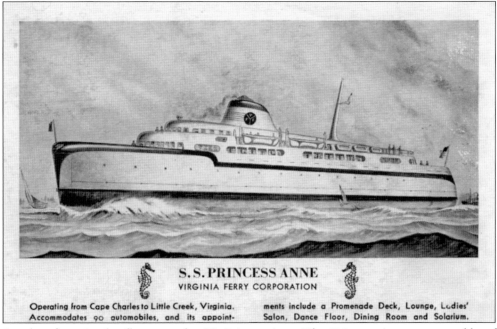

S.S. PRINCESS ANNE
VIRGINIA FERRY CORPORATION

Operating from Cape Charles to Little Creek, Virginia. Accommodates 90 automobiles, and its appoint- ments include a Promenade Deck, Lounge, Ladies' Salon, Dance Floor, Dining Room and Solarium.

Another ferry in the fleet was the SS *Princess Anne*. The Princess Anne was capable of transporting 90 vehicles and, for the comfort of the passengers, included a lounge, a ladies' salon, and a solarium.

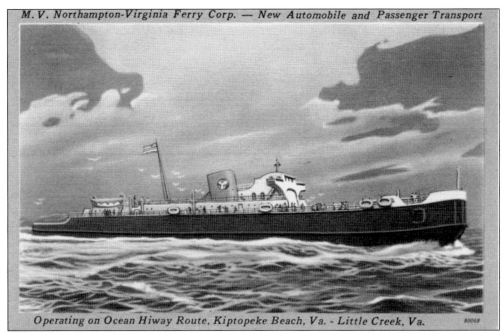

M. V. Northampton-Virginia Ferry Corp. — New Automobile and Passenger Transport

Operating on Ocean Hiway Route, Kiptopeke Beach, Va. - Little Creek, Va. 80058

This undated postcard shows the MV *Northampton* as she makes the 21-mile passage across the Chesapeake Bay. A motorvessel (MV) rather than a steamship (SS), the *Northampton* offered fewer luxuries for the passengers, but it provided reliable transportation for 75 cars and saved travelers hundreds of miles on the road.

The Virginia Beach

In 1956, the ferry service was taken over by the Chesapeake Bay Ferry Commission and an east-to-west route was added, providing service from Kiptopeke Beach to Old Point Comfort. Another purpose of the commission was to study the feasibility of building a bridge across the Chesapeake Bay to replace the ferries. When this card was mailed in 1962, the Chesapeake Bay Bridge and Tunnel (CBBT) project was well underway. The new CBBT opened in 1964, and the ferry service became a thing of the past.

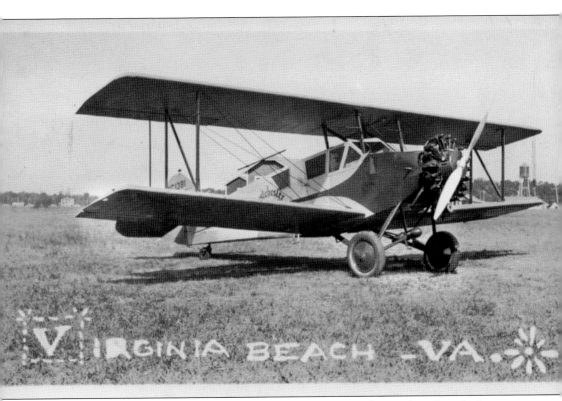

"I got this card when I was on the beach. I had a pretty good time there," reads the message on the back of this unaddressed, undated card. It can be gathered from the water tower and the many tents in the background that this plane landed at Fort Story at the north end of Virginia Beach, probably in the late 1920s.

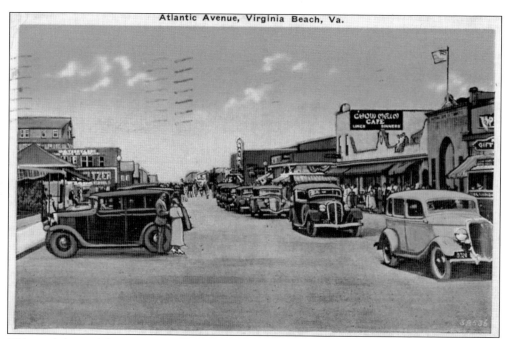

This card shows Atlantic Avenue near Seventeenth Street on a clear, sunny day, but the couple who sent it to their family in Indiana had a different experience. "The place got pretty well blown around in the hurricane but when they dig out from under all the sand it will look like Michiana." The card is dated September 22, 1938.

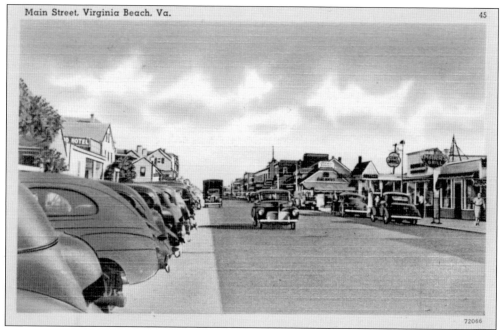

Main Street, Virginia Beach, Va. 45

Not much changed about Atlantic Avenue in the 10 years after the previous card. Forty-five degree angle parking was allowed on the east side of the street to allow more people access to the beach.

18

Two

PLACES TO GO

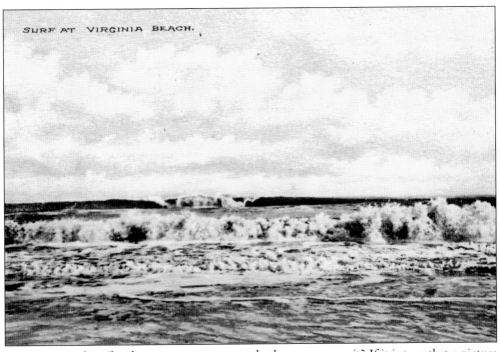

SURF AT VIRGINIA BEACH.

How can you describe the ocean to someone who has never seen it? If it is true that a picture is worth a thousand words, then this card should provide an excellent description. Many people who visited Virginia Beach had never seen the ocean before and wanted to share their experience with friends back home.

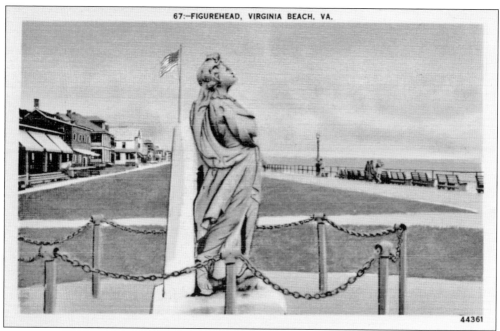

44361

In 1891, a Norwegian ship, *Dictator*, sank off the Virginia Beach coast, and the captain's wife and three-year-old son drowned. When the ship's figurehead washed ashore, it was set up as a sort of shrine. Over the years, tens of thousands of visitors came to see, touch, and even carve souvenir pieces from the majestic "Norwegian Lady."

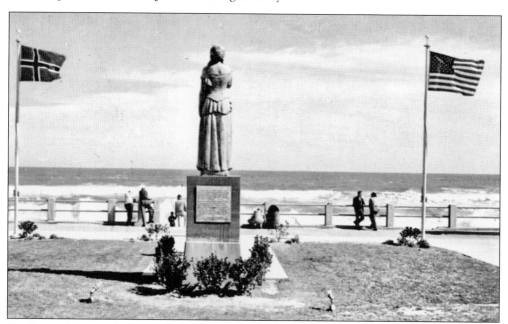

Erosion and time took their toll on the old figurehead. After being damaged in a storm in 1953, the monument was removed for storage but was lost. Two beautiful new statues were dedicated in 1962, one at Twenty-fifth Street in Virginia Beach and the other in Moss, Norway, home port of the *Dictator*.

20

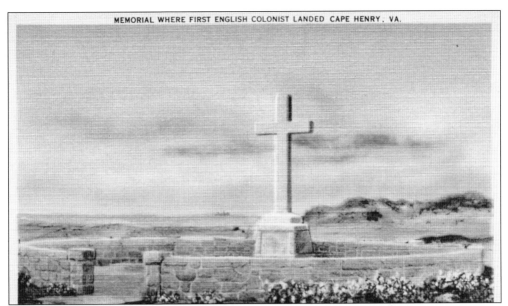

To commemorate the first landing of English settlers in 1607, this granite cross was erected by the National Society of the Daughters of the American Colonists and dedicated in 1935. The monument is now a national landmark.

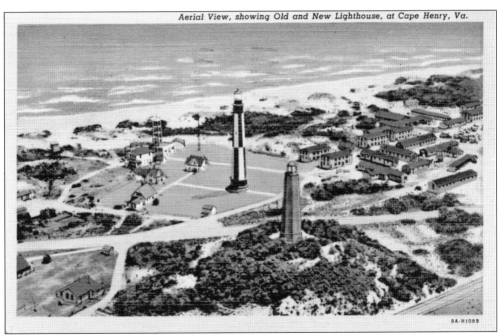

Aerial View, showing Old and New Lighthouse, at Cape Henry, Va.

The two lighthouses are the most photographed structures in Virginia Beach. The original was constructed in 1791 and is the oldest federally built lighthouse in the United States. In 1881, a new lighthouse went into service, but its predecessor was left proudly standing atop a large sand dune. This aerial view was postmarked August 31, 1942.

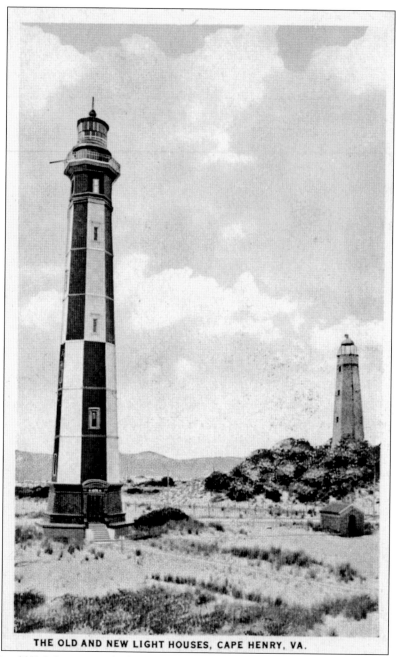

THE OLD AND NEW LIGHT HOUSES, CAPE HENRY, VA.

In 1872, the old lighthouse was declared unsafe and preparations were made for the construction of a replacement. The site chosen was 357 feet from the existing structure, and the plans called for a 150-foot-tall, cast-iron lighthouse on a concrete base. Morris, Tasker & Company of Philadelphia assembled the tower. The crystal lens was manufactured in Paris. A 160,000-candlepower, electric light was installed in 1923. Six years later, the lighthouse began flashing the letter "U" in Morse code indicating that it was an "unwatched," or automatic, tower. It was the first radio-distance-finding station in the world and is the tallest, fully enclosed, cast-iron lighthouse in the country.

22

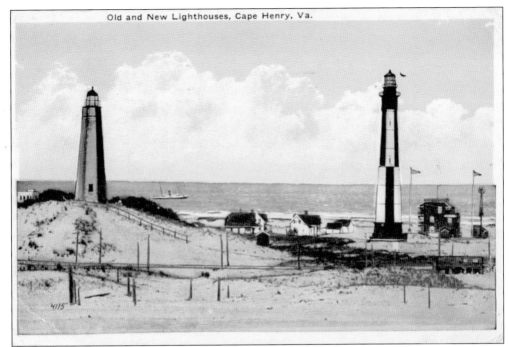

Old and New Lighthouses, Cape Henry, Va.

This view shows the two lighthouses as seen from the south. Harry P. Cann & Brothers, publishers of this card, incorrectly date the old lighthouse to 1690. The correct date should be 1792. The weather station and the Cape Henry train station can be seen on the right side.

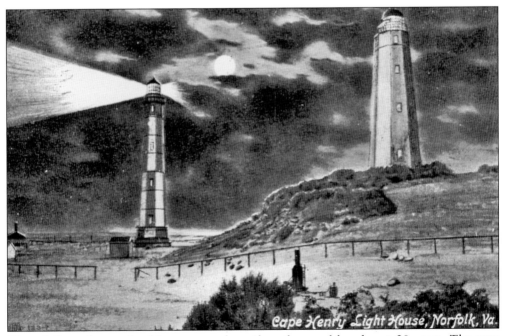

Cape Henry Light House, Norfolk, Va.

Viewed from the north, this scene predates the other card by almost 20 years. The note is labeled August 1, 1907, 8:00 p.m., so it seems appropriate that the writer would send a night image.

This building was constructed at Cape Henry in 1874 and served as a station for the U.S. Weather Bureau and an office for the Department of Agriculture. The station was moved in 1938 because firing the big guns at Fort Story disturbed the delicate instruments. The building was demolished in 1953.

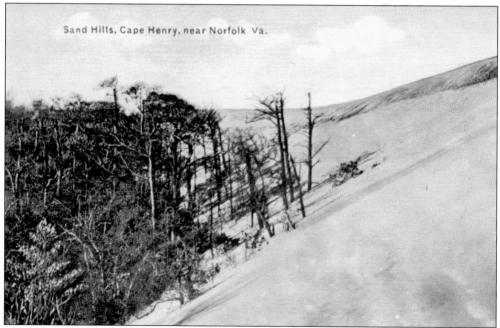

Sand Hills, Cape Henry, near Norfolk. Va.

The natural beauty of Virginia Beach has always been a popular attraction. The formation of dunes this size would take hundreds of years. Until the 1940s, dunes like this were common along the north shore of the city, but many were leveled in the name of progress. Fortunately, some of the area is preserved in its original condition at the First Landing State Park.

In October 1937, a monument was unveiled at the end of Seventeenth Street near the boardwalk, marking the eastern end of the Daniel Boone Trail. Boone is credited with exploring territory from the Atlantic Coast to the Missouri-Kansas border. According to the Boone Trail Association, Boone and a group of pioneers first laid eyes on the Atlantic Ocean somewhere near that location. The monument was one of 366 markers along the trail, which was the forerunner of Route 60. Two plaques were mounted to the arrowhead-shaped stone monument: one was an image of Boone holding his rifle, and the other was the bust of an Algonquin Indian, whose tribe had established their own trail from Boston to Roanoke Island, North Carolina. Boone supposedly used their trail and befriended the Algonquins. Both of these cards were altered to show the American flag, which was not part of the monument, and the sailing ship. The same background image was used in several different cards.

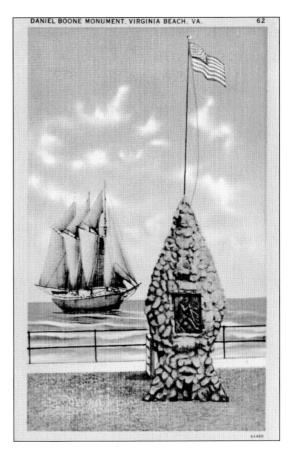

DANIEL BOONE MONUMENT. VIRGINIA BEACH, VA. 62

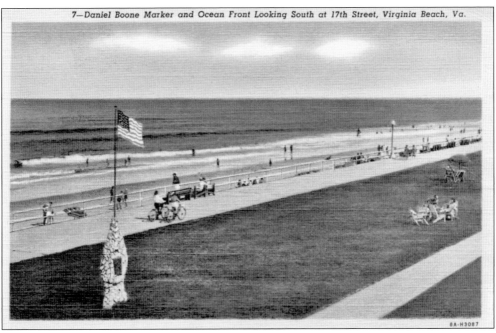

7—Daniel Boone Marker and Ocean Front Looking South at 17th Street, Virginia Beach, Va.

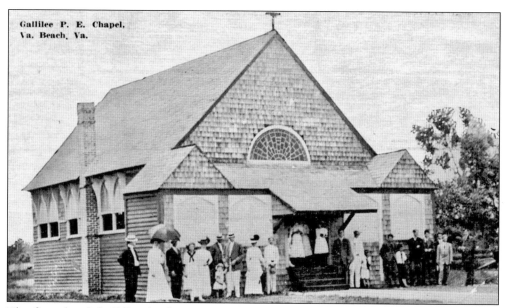

Gallilee P. E. Chapel,
Va. Beach, Va.

The first church building in the resort area, constructed in the early 1890s, was located at Eighteenth Street at the oceanfront. It was called the Union Chapel because it provided services for all denominations. By 1895, the various denominations were establishing their own churches. Union Chapel became known as Galilee by the Sea, an Episcopal mission of the Eastern Shore Chapel. Although the postmark on this card is 1911, the church changed from the Galilee P.E. (Protestant Episcopal) Chapel to the Galilee Episcopal Church in 1903 after severing its ties with the Eastern Shore Chapel.

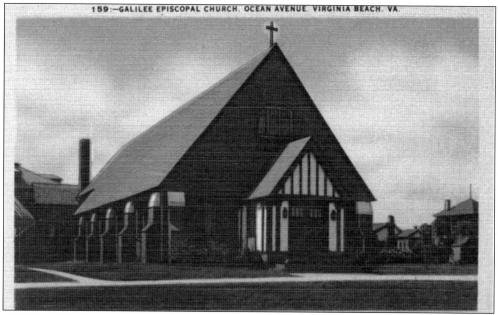

159:—GALILEE EPISCOPAL CHURCH, OCEAN AVENUE, VIRGINIA BEACH, VA.

A new church, pictured here, was built next to the old one in 1926. The original building was used for Sunday school and later as a parish house. By 1956, the congregation had outgrown this building; Galilee Episcopal Church was moved to Fortieth Street and Pacific Avenue.

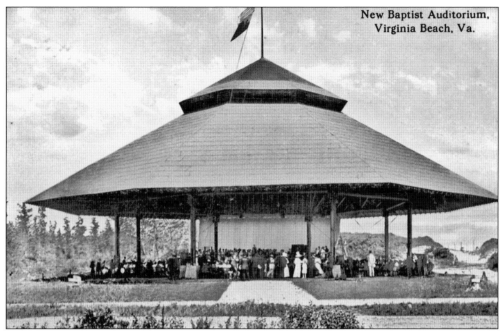

With only nine charter members, the First Baptist Church of Virginia Beach began construction in 1908 at the corner of Seventeenth Street and Artic Avenue. A tabernacle, or auditorium, was soon added and was called the Chautauqua Building, after the 1874 Baptist encampment at Lake Chautauqua, New York. Each summer from 1910 to 1932, the Baptist encampment was held in Virginia Beach.

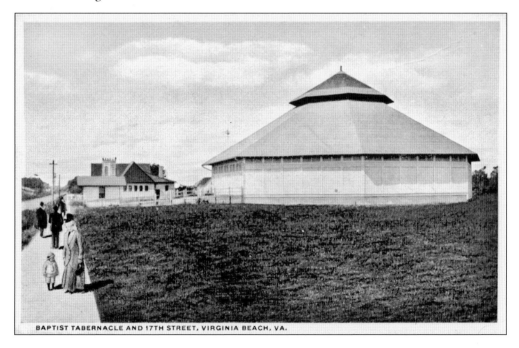

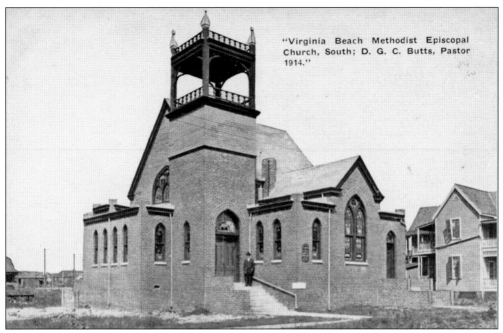

"Virginia Beach Methodist Episcopal Church, South; D. G. C. Butts, Pastor 1914."

In 1912, the local Methodists built their own church at Eighteenth Street and Pacific Avenue. The picture used for this card was taken in 1914. The building has undergone many renovations; the only part still in the original place is the front entrance.

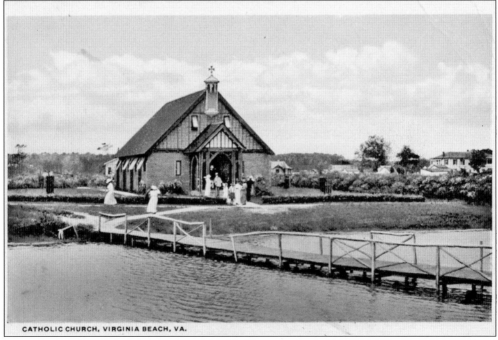

CATHOLIC CHURCH, VIRGINIA BEACH, VA.

Star of the Sea Catholic Church was constructed at Fourteenth Street and Pacific Avenue in 1915 under the leadership of Rev. Philip Brennan. Although the card is undated, it is known that the statue of the Virgin Mary was added in 1921.

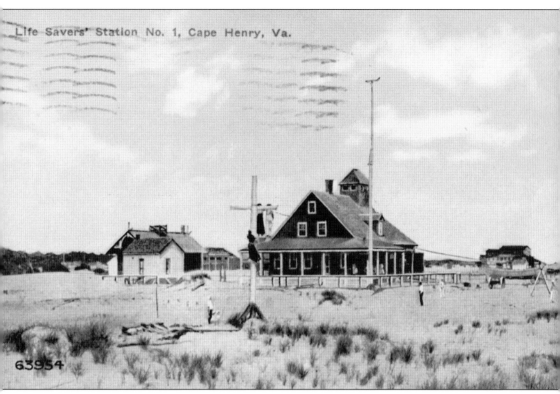

Life Savers' Station No. 1, Cape Henry, Va.

63954

At the four U.S. Life-Saving Stations in Princess Anne County, visitors could watch the surfmen doing their drills. This card, postmarked in 1910, shows the men of the Cape Henry station practicing life-saving techniques. The writer tells his friend, Ella, "This is where you get saved when you fall in the water."

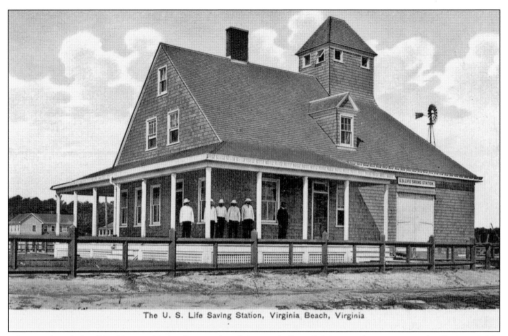

The U. S. Life Saving Station, Virginia Beach, Virginia

The U.S.L.S.S. #2 (Seatack) is shown in this card dated 1907. This station, built in 1903, replaced the original, smaller building that had been on the site since 1878. From 1878 until the U.S. Coast Guard took over operations in 1915, the men of the Seatack station responded to 189 shipwrecks.

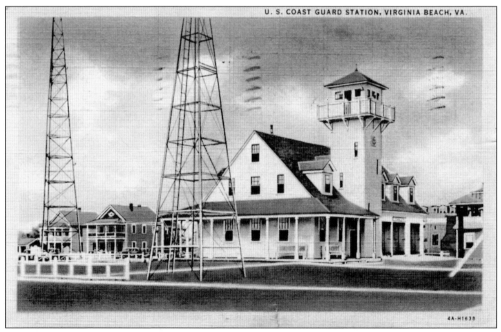

In 1933, the Seatack station was updated a second time. The equipment area was enlarged, and the watch tower was moved from the center of the building. A few years later, a wireless radio antenna was constructed. The station was decommissioned in 1969 and is now a museum.

PUBLIC SCHOOL, VIRGINIA BEACH, VA.

The Willoughby T. Cooke School, built in 1913, is located at Fifteenth Street between Mediterranean and Baltic. Although it is not the oldest school in Virginia Beach, it is perhaps the longest-operating school in its original location. This card was mailed four years after the school opened.

In 1954, the first class graduated from Princess Anne High School in Lynnhaven, home of the Cavaliers. This aerial photo was taken shortly after that and was made into a postcard (this one was never used). The school stood alone then, but it is now surrounded by houses, malls, and churches.

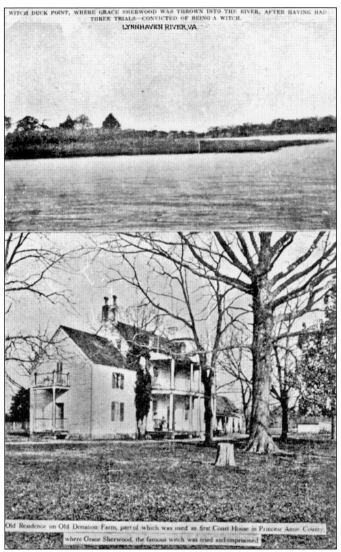

WITCH DUCK POINT, WHERE GRACE SHERWOOD WAS THROWN INTO THE RIVER, AFTER HAVING HAD THREE TRIALS—CONVICTED OF BEING A WITCH.
LYNNHAVEN RIVER, VA.

Old Residence on Old Donation Farm, part of which was used as first Court House in Princess Anne County, where Grace Sherwood, the famous witch was tried and imprisoned

In 1706, after being accused of practicing witchcraft, Grace Sherwood consented to a trial by water. Taken by boat into the Lynnhaven River, she was tied "crossbound," with her right thumb to her left big toe and her left thumb to her right big toe. While hundreds of people yelled, "Duck the witch," Grace was thrown overboard. Law said that if she drowned she was innocent, but if she survived she would be deemed a witch and killed. Grace lived. Because of the hysteria that led to the deaths of innocent women in Salem, Massachusetts, there was no hurry to put Grace to death; she was jailed instead. After nine years, Grace was released to her farm in rural Pungo where she died years later. She is known today as the "Witch of Pungo." The point of land that jutted into the Lynnhaven River near where Grace was "ducked" became known as Witchduck Point. A local plantation, known as the Ferry House, has gained notoriety because of its role in the trial. The plantation is mistakenly believed to be the site of the courthouse where Grace was tried, but it was not. The actual courthouse was close by. However, hundreds of people gathered at the plantation to watch the "ducking" that took place in the river less than 100 yards from the shore. The house, a private residence until 1987, was abandoned for 12 years. Restored, it is now open to the public.

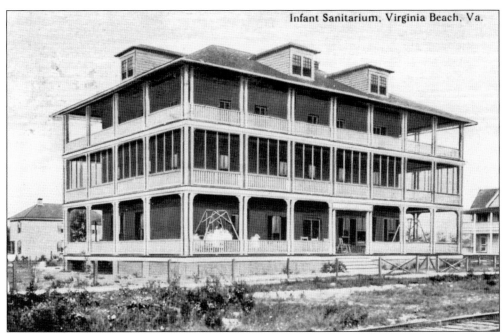

Infant Sanitarium, Virginia Beach, Va.

This card postmarked 1913 shows the Infant Sanitarium at Eighteenth Street and Atlantic Avenue. This institution operated from 1888 to 1946, providing free medical care to infants and children of poor families. The Norfolk and Virginia Beach Railroad donated the land and provided transportation, free of charge, to parents bringing their children to the hospital.

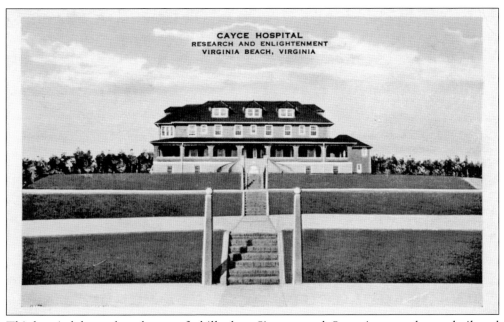

CAYCE HOSPITAL
RESEARCH AND ENLIGHTENMENT
VIRGINIA BEACH, VIRGINIA

This hospital, located on the top of a hill where Sixty-seventh Street is currently, was built and operated by the well-known psychic Edgar Cayce and served as a source of alternative medical care. Cayce opened the center in 1928 and, two years later, founded Atlantic University. Both the hospital and the university failed, and the building was sold in the early 1930s.

THE OLD THOROUGHGOOD HOME IN PRINCESS ANNE COUNTY. NEAR NORFOLK. VA.

4

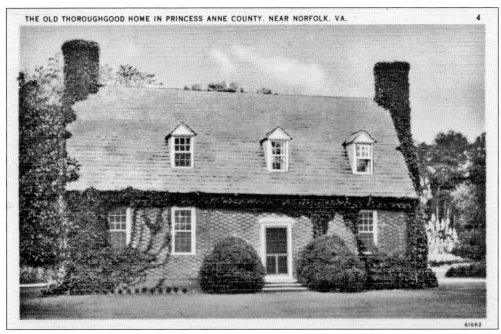

61662

This house was built on Adam Thoroughgood's estate, which dates back to the establishment of Lower Norfolk County in 1635. (The area became Princess Anne County in 1691.) Historians have determined that the house, erected in 1680, is the oldest house of English brick construction in the United States. It was privately owned until 1951, and in 1957, when reconstruction was completed, the house opened to the public.

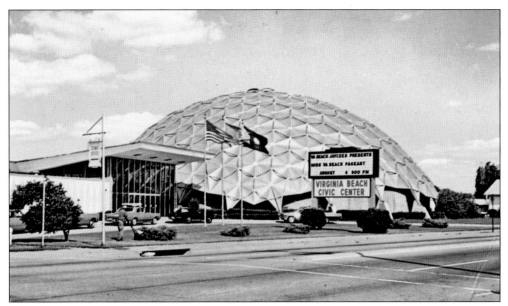

Built in 1958 as the city's convention center, this Buckminster Fuller design was the first geodesic building in the country. The center offered 15,000 square feet of exhibit, seating, and banquet space. Locally known as "the dome," its official name was changed to the Alan B. Shepard Civic Center in 1963 to honor the astronaut and former resident.

Three

Places to Stay

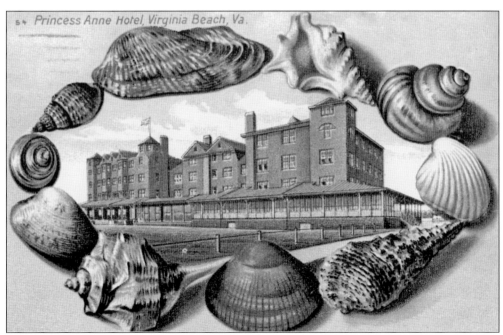

When the Virginia Beach Hotel failed in 1887, the building was closed and major improvements were made. It reopened as the Princess Anne Hotel in 1888. Although destroyed by fire fewer than 20 years later, her beauty and courtliness had become legendary, representing the elegance of Virginia Beach. This card is postmarked 1917.

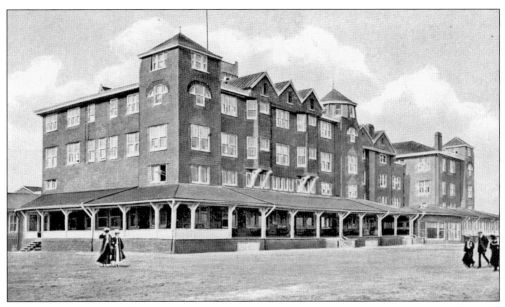

Stretching from Fourteenth Street to Sixteenth Street, the Princess Anne Hotel could accommodate 400 guests year round. The luxurious guest rooms, fresh and saltwater baths, post office, Western Union telegraph, ballrooms, elevators, veranda, and sun parlors attracted the elite from all over the country. The hotel hosted Alexander Graham Bell, Mrs. J.E.B. Stuart (wife of the Confederate general), and Presidents Grover Cleveland and Benjamin Harrison.

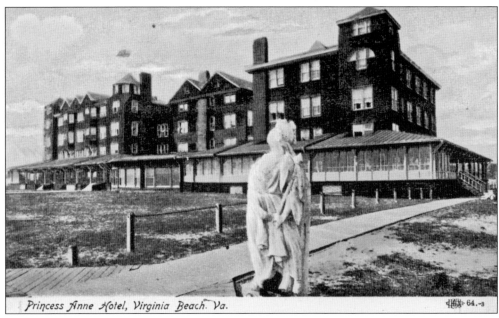

Princess Anne Hotel, Virginia Beach. Va.

In March of 1891, the Norwegian bark *Dictator* ran aground, resulting in the loss of 8 of the 17 souls on board. Among the dead were the captain's wife and three-year-old son. Guests of the hotel witnessed the wreck and the rescue attempts and donated $400 cash to the survivors. When the ship's figurehead washed ashore in front of the hotel several days later, it was displayed as a memorial to the tragedy.

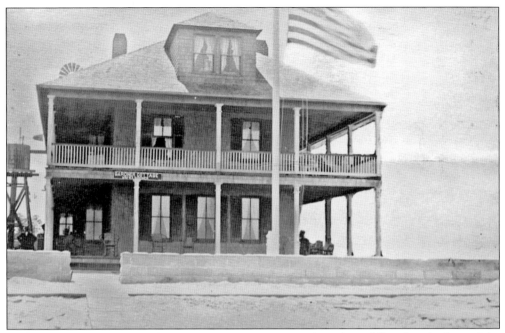

Many homes originally built as summer cottages opened to the public after the loss of the Princess Anne Hotel. This card shows the Gardner Cottage, near Nineteenth Street and the oceanfront. One guest wrote home to Philadelphia in 1908 noting that the ocean water was "bromidic" (salty).

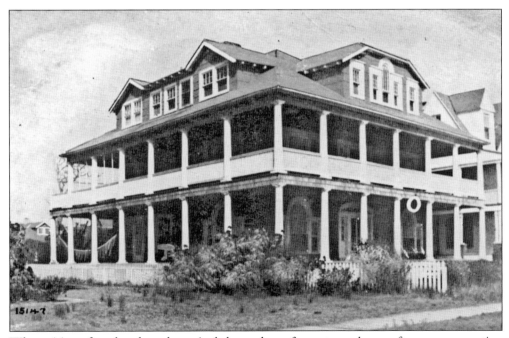

When visitors found a place that suited them, they often returned year after year, generation after generation. The Shorham cottage was first occupied in 1888 and was converted to a hostelry around 1915. It was still receiving guests when this card was mailed in 1940.

37

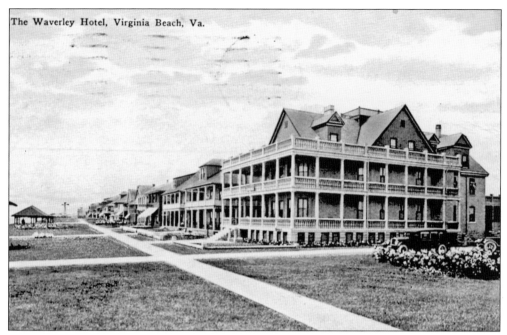

The Waverley Hotel, Virginia Beach, Va.

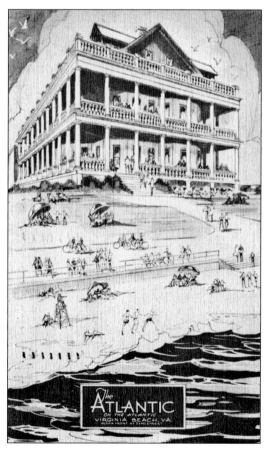

The Waverly, pictured on the above card dated July 1928, was another summer cottage built before the turn of the century. Around the same time, the hotel moved to a new building just across the street, and the old building reopened as the Atlantic Hotel. The card postmarked 1949 (left) advertises summer rates as $5.50 to $6 per person. Off season rates were $2.50 to $4. This building was demolished in 1975.

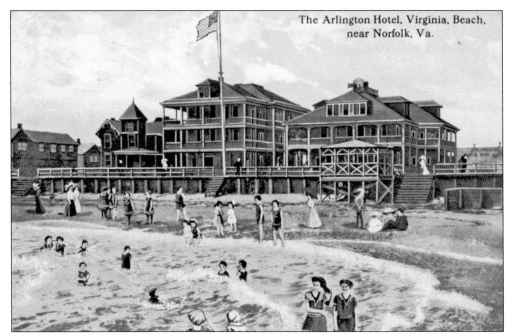

The Arlington Hotel, Virginia, Beach, near Norfolk, Va.

Opened in 1888, the Arlington was one of the first hotels built to compete with the Princess Anne. Although not of the same scale or grandeur, the Arlington was a very popular spot for visitors, offering a belvedere actually built out in the sand. Around 1915, the hotel was purchased by the Baptist church to house the hundreds of people who came to the annual summer encampment.

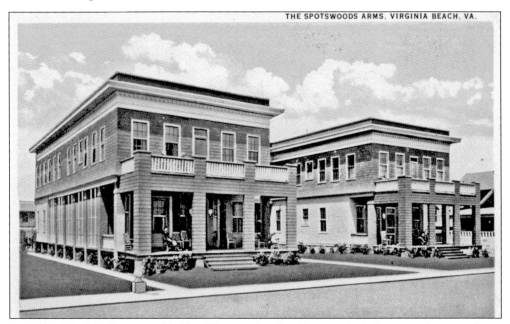

THE SPOTSWOODS ARMS, VIRGINIA BEACH, VA.

In 1908, Col. C.F. Spotswood built a 50-room hotel at Twenty-sixth Street on the oceanfront. The Spotswood Arms was sold in 1926 for a reported $85,000. Over the next 40 or so years, the building underwent numerous renovations, but the name never changed.

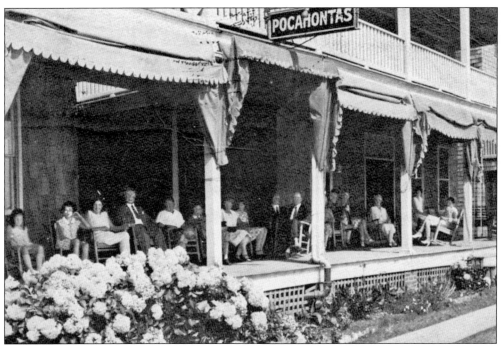

The majestic Pocahontas Hotel was also constructed in the early 1900s and was one of the few locations open all year. This card, sent in 1932, features guests relaxing on the porch. Eva wrote to her friends, "Cannot describe the feeling one has on seeing the ocean for the first time."

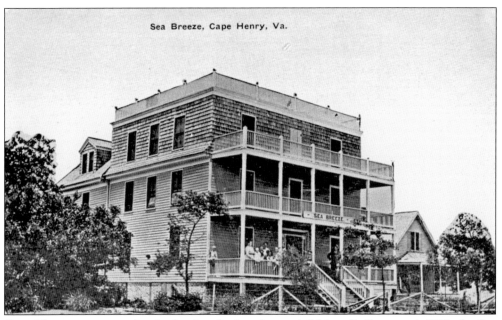

Cape Henry was a popular destination for hunting and fishing. Built around 1912, the Sea Breeze Hotel was conveniently located across from the train station. For the vacationing businessmen, the Sea Breeze was "Near Post Office, Telegraph Office and only 10 minutes to the famous fishing grounds."

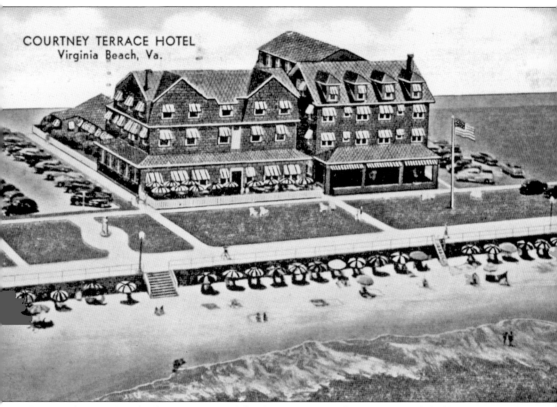

COURTNEY TERRACE HOTEL
Virginia Beach, Va.

On March 15, 1906, the first city council for the new town of Virginia Beach held its inaugural meeting at the Princess Anne Hotel. One of those men was William J. O'Keefe, who owned a small inn next door. Not long after the fire that destroyed the Princess Anne, O'Keefe began improvements on his property, and the name was eventually changed to the Courtney Terrace. It is apparent from this picture that the hotel had several additions. Notice the figurehead of the *Dictator* near the southeast corner of the hotel.

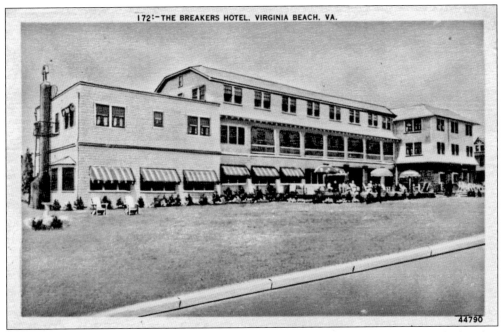

The Breakers Hotel also underwent many architectural changes over several decades. Originally a gun club, it was located next to the life-saving station at Twenty-fifth Street and completed in 1890. In 1929, the building was converted to a hotel. It was modernized a final time prior to its closing in 1968.

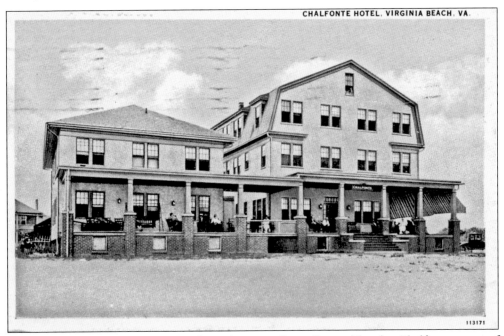

The 1920s brought many new hotels to the oceanfront. Some, like the Chalfonte, were of a more traditional design. This postcard was mailed in 1941, but the picture predates the concrete boardwalk, which was constructed in 1927.

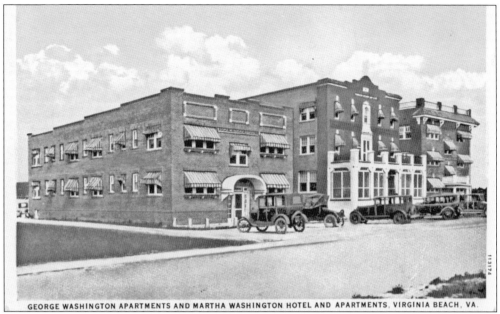

GEORGE WASHINGTON APARTMENTS AND MARTHA WASHINGTON HOTEL AND APARTMENTS, VIRGINIA BEACH, VA.

In 1925, construction began on two brick apartment buildings at Eighth Street and Pacific Avenue. The George Washington was two stories and the Martha Washington was three. The next year, the Martha Washington Hotel was erected between the two new buildings. To avoid confusion, George's name was dropped, and the complex existed for several decades as the Martha Washington Hotel and Apartments.

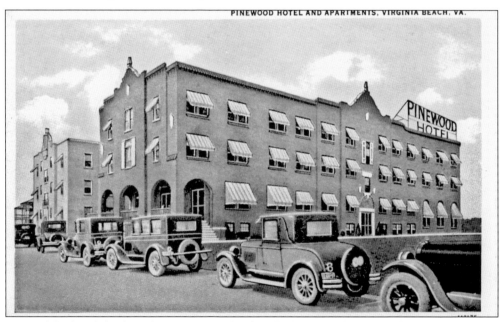

Most of the hotels built in the 1920s were brick, which changed the complexion of the resort area. The three-story Pinewood Hotel and the Traymore Apartments were both completed in 1927. Located between Ninth and Tenth Streets, the Traymore was converted to a motel in 1946, and a few years later, the Pinewood became part of the Dunes Hotel.

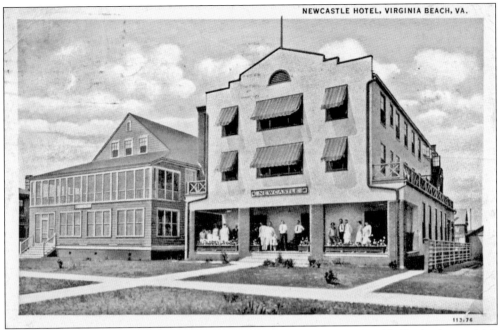

The Newcastle was completed in 1926, the same year as the adjacent Seaside Sanitarium, which would eventually become part of the hotel. In 1944, George sent this card to Jack, saying, "The fourth of July will not be a success without you so get up a party and come on down."

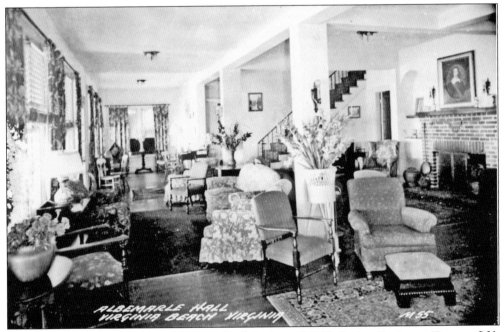

The Albemarle Hall was located just south of the Seatack Life-Saving Station at Twenty-fifth Street. It opened in the early 1920s, and in 1925, it annexed the Payne Cottage next door. This is a view of the lobby of the hotel. There was also a cocktail room called the Frog Pond for the bring-your-own-bottle crowd.

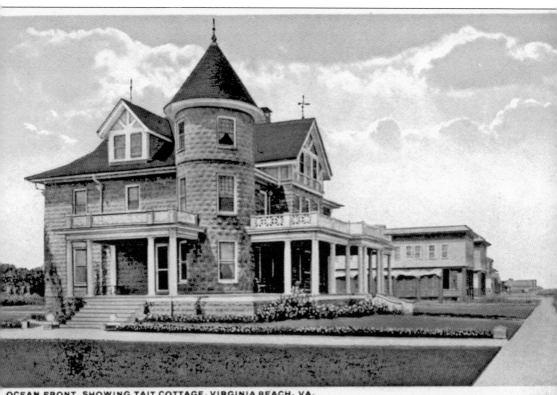

Built of solid stone blocks with a three-story turret in one corner, the Groves Cottage was one of the most expensive in town. The Tait family bought and occupied the house, which had 11 bedrooms and 6 baths. In 1922, the home was purchased again, this time by a group of developers, who added 110 additional rooms. The following year, the second Princess Anne Hotel was opened. The new owners, the Sterling family, lived in the original cottage portion of the structure and maintained a livery stable across the street. The hotel included a dining room that overlooked the ocean and living quarters for the servants.

VIRGINIA BEACH -- VIRGINIA

Virginia Beach is situated eighteen miles due east of Norfolk and is accessible by electric ca and by automobile and motorbus over concrete boulevards.

The Beach is only a night's ride from New York, Philadelphia, Baltimore, Washington a most of Virginia and the Carolinas, and *is within a day's ride of half of the population of t United States.* It has much to offer to the man of wealth seeking a delightful location for a su mer or winter home. There is no finer place anywhere—there is no duplicate. It off something to keep the visitor or resident pleasantly busy and interested practically every day his stay. It is ideally located for a week-end trip from the immediate northern and southern citi

• • •

PRINCESS ANNE HOTEL
On the Ocean Front at 25th St.

Delightfully situated on the ocean front. A home-like atmosphere for refined Christian people.

American Plan.
Southern Cuisine.
Modern throughout.

Bright, airy rooms with baths.

All outside; attractively furnished.

Hot and Cold Running Water.

Privilege of two picturesque 18 hole g courses, which are within a short distan

This postcard (continuing onto the opposite page) was mailed to prospective guests on request. It advertised the Princess Anne Inn as well as the town of Virginia Beach, showing off the concrete boardwalk, completed in 1927. "Virginia Beach is within a day's ride of half of the population of the United States. It has much to offer to the man of wealth seeking a delightful location for a summer or winter home. There is no finer place anywhere—there is no duplicate. It offers something to keep the visitor or resident pleasantly busy and interested practically every day of his stay. It is ideally located for a week-end trip from the immediate northern and southern cities." The Princess Anne Hotel remained open to guests until 1963.

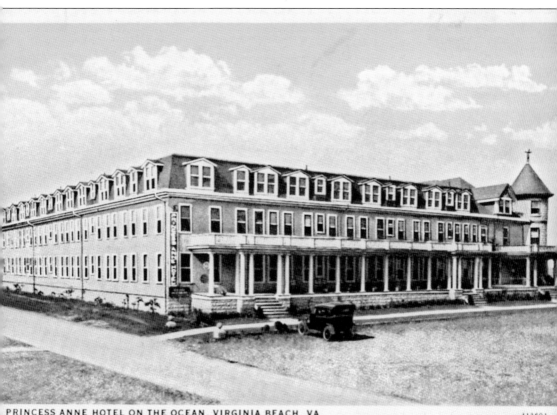

PRINCESS ANNE HOTEL ON THE OCEAN, VIRGINIA BEACH, VA.

It was demolished the following year and replaced with the modern Princess Anne Inn, owned and operated by the same family. The Princess Anne Hotel is "Delightfully situated on the ocean front—A home-like atmosphere for refined Christian people—Southern Cuisine—Bright, airy rooms with baths—Privilege of two picturesque 18-hole golf courses which are within a short distance."

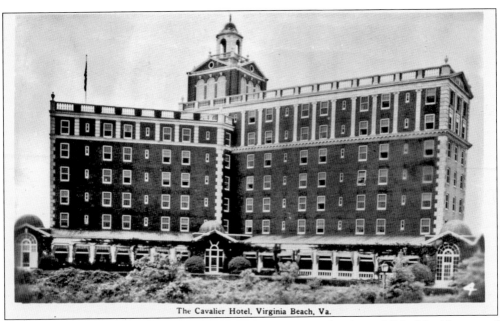

The Cavalier Hotel, Virginia Beach, Va.

The Cavalier Hotel opened its doors in April 1927 and immediately established itself as one of the finest hotels in the country. Over the years, guests have included nine U.S. presidents and countless Hollywood celebrities. The WSEA radio station, located in the lobby, made the hotel the third place in the country to have coast-to-coast broadcasting.

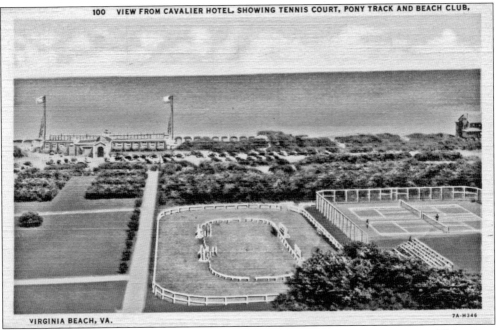

100 VIEW FROM CAVALIER HOTEL, SHOWING TENNIS COURT, PONY TRACK AND BEACH CLUB,

VIRGINIA BEACH, VA. 7A-H346

The Cavalier Hotel was located at Forty-second Street and Atlantic Avenue. This view, looking east, shows the horse track, the tennis court, and the beach club, all on Cavalier property. There was also an 18-hole golf course and several miles of trails for walking or horseback riding.

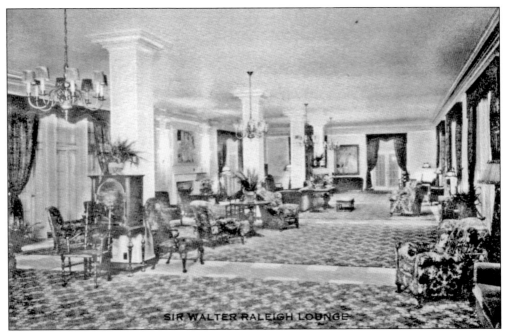

"You must see this place, its fine." That's what the writer of this card said in 1929. This is the Walter Raleigh Lounge, one of many common areas in the hotel. The Cavalier was considered the social center of Virginia Beach.

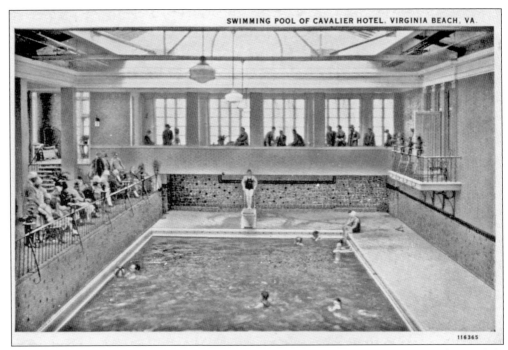

Even the indoor pool, with lounges overlooking the swimmers, was a place to socialize. While the ocean was available nearby, many people preferred the more luxurious pool, which was filled with filtered salt water and was enjoyed by guests year round.

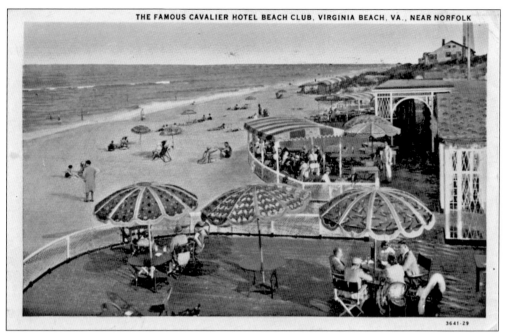

The Cavalier Beach Club was added in May of 1929. In addition to outdoor swimming and dining, it also provided an open-air dance floor. The Cavalier hired a different band every week, offering more than any other location in the nation. The artists included Jimmy Dorsey, Glenn Miller, Arte Shaw, Frank Sinatra, and Lawrence Welk. This card is postmarked 1931.

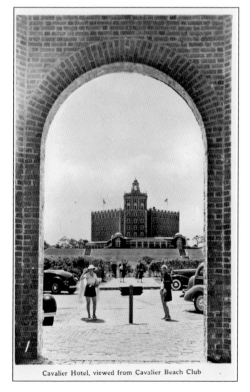

Cavalier Hotel, viewed from Cavalier Beach Club

The Cavalier also offered beach cabanas, not just for the guests, but also for locals. The cabanas were actually small day-use cottages and could be rented for around $400 a season. In 1933, a hurricane destroyed the Cavalier Beach Club and the cabanas, but they were quickly rebuilt.

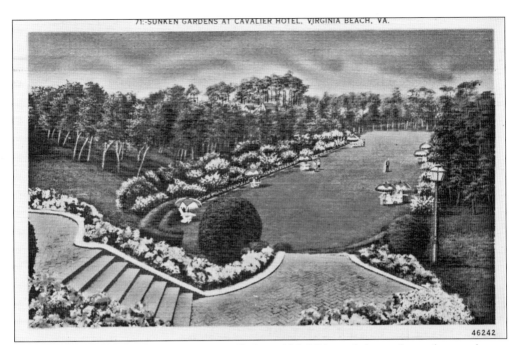

The rest of the Cavalier property was equally beautiful. This card shows the sunken gardens at the rear of the hotel. Most of the floral arrangements that decorated the hotel's interior were made from flowers grown here. The food was brought in fresh by train every day. The hotel had several fine dining rooms, including one for chauffeurs only.

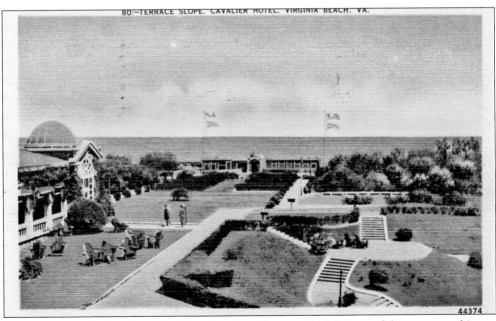

The terrace on the hotel's south side offered another wonderful view of the ocean, and it was that view that brought the navy to the Cavalier at the beginning of World War II. During the war years, the hotel was taken over by the navy for use as a radar training school. In 1945, the hotel reverted back to private ownership, but the best years of the hotel had passed.

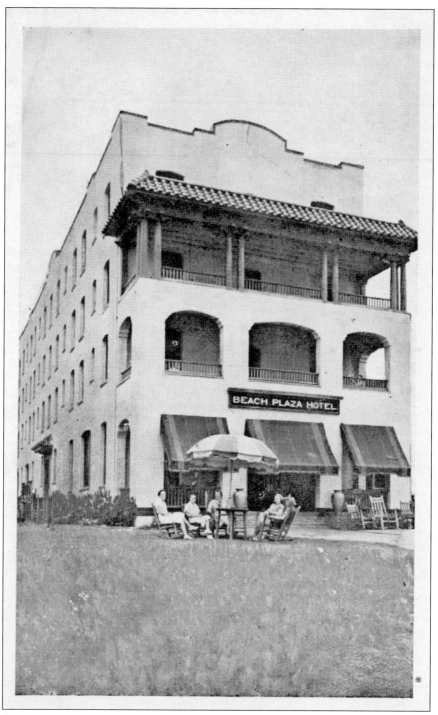

The Edgewater Hotel was built in the early 1920s and was located on Atlantic Avenue between Twenty-second and Twenty-third Streets. The hotel was severely damaged by fire in 1929. After being repaired, it was reopened as the Beach Plaza and remained an oceanfront landmark for several decades.

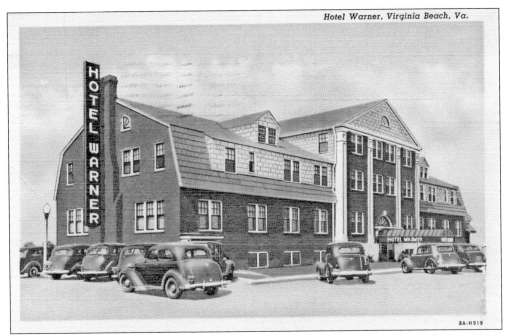

In the 1930s, oceanfront property was getting scarcer and more expensive, and competition between hotels was getting intense. When the Hotel Warner opened in 1936, it was unique in its Dutch colonial design with red brick and green roof and in its orientation facing south, not east toward the oceanfront. In spite of this, or perhaps because of it, the hotel did well and survived into the 1980s.

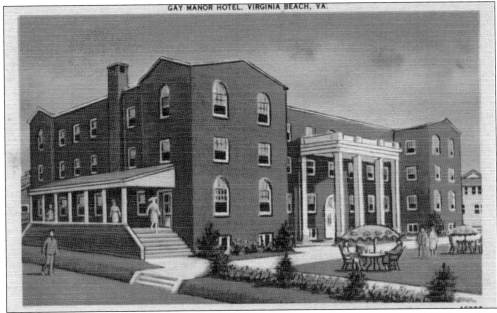

In 1938, construction started on the Gay Manor Hotel on Atlantic Avenue and Thirty-ninth Street. Mr. Gay, following the example of the Hotel Warner, built his hotel perpendicular to the ocean. Originally constructed with only three floors, the hotel later added a fourth.

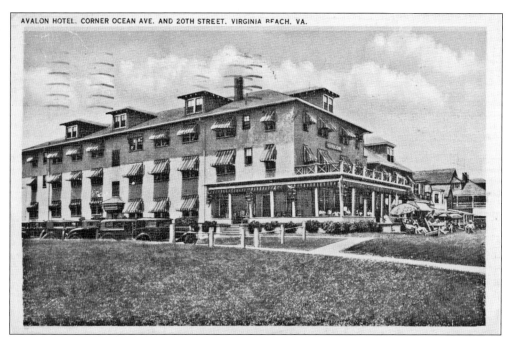

Although the Avalon was originally opened in 1918, there were major additions made about every 10 years. This card was mailed in 1934, just prior to another renovation. The hotel remained in business until it was destroyed by fire in 1983.

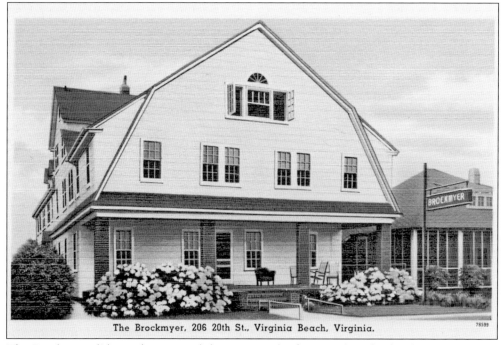

The Brockmyer, 206 20th St., Virginia Beach, Virginia.

The Brockmyer did not change much but remained a favorite place for families returning to the beach year after year. "Exclusive, but not expensive," the hostelry was located just one block from the ocean.

Apartment buildings became more and more common at the oceanfront. The Beachome Apartments, built in the mid-1920s, were located at Twenty-eighth Street and Atlantic Avenue. Unlike most cards, which were printed out of state, this card was made locally by Becksell Postcard Company in Norfolk.

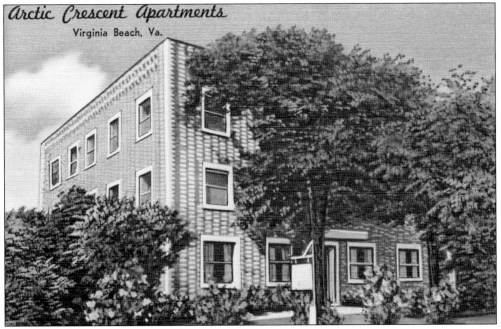

The Arctic Crescent Apartments were located at 309 Fifteenth Street, across from the Star of the Sea Catholic Church. According to this advertisement, "all rooms are constructed of fireproof masonry and beautiful terrazzo floors." Guests could rent a two-bedroom, air-conditioned, corner apartment, fully furnished, with utilities included, for $90 a week.

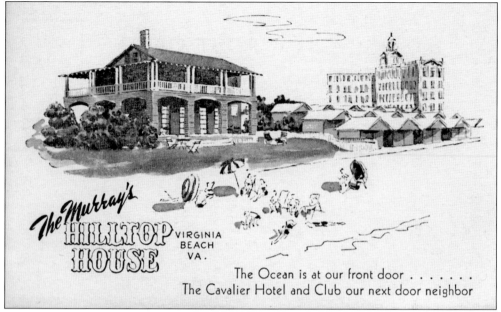

For the Hilltop House, location was everything. This card has no mention of the hotel's own amenities; it simply relies on the stellar reputation of the neighboring Cavalier as a selling point. An advertisement on the back of the card says it well: "The Location is Tops."

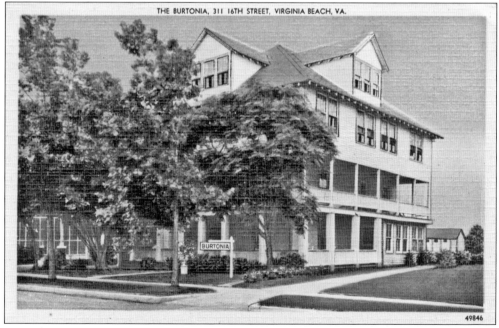

Location was not an issue for the Burtonia, whose address was 311 Sixteenth Street. Although slightly off the beaten path, the hostelry remained popular for several decades by offering guests affordable rates and courtesy cards allowing entrance to all the nearby clubs.

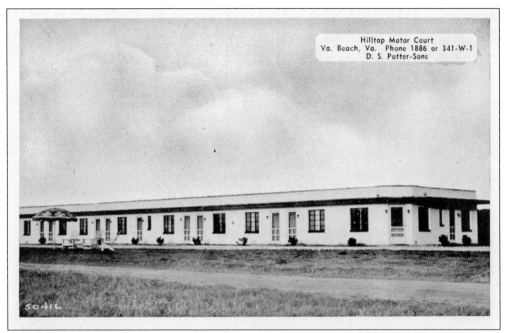

Shortly after World War II, new types of accommodations were available to vacationers: motels and motor courts. Possibly the first to be opened in Virginia Beach was the Hilltop Motor Court, located two miles west of the oceanfront. The business was owned and operated by D.S. Potter, who had built a gas station across the street three years earlier.

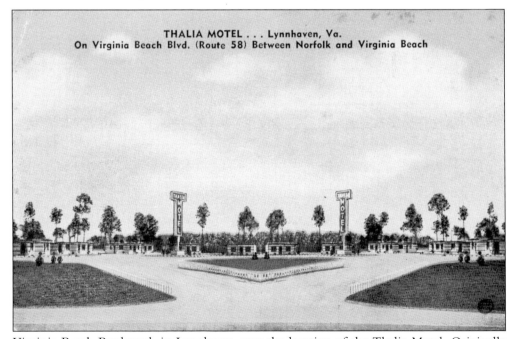

Virginia Beach Boulevard, in Lynnhaven, was the location of the Thalia Motel. Originally part of Camp Thalia/Ashby, the small bungalows were converted after the war and remained in service as a motel until the mid-1960s.

WHITE OAK CABINS, on U. S. Route 58, One-half mile from Ocean

LONDON BRIDGE CABINS, on U. S. Route 58, Four miles from Ocean

The Capps family operated the London Bridge Cabins near the intersection of Virginia Beach Boulevard and Great Neck Road. The establishment was so popular that the Cappses opened a second business, White Oak Cabins, closer to the oceanfront.

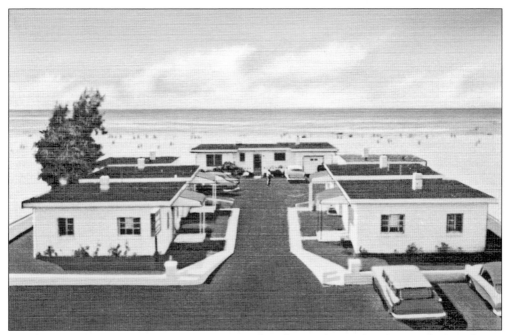

Another area that was attractive to tourists was the Chesapeake Bay beach, near the Lynnhaven Inlet. The Sunset Motel, on Page Avenue, was convenient to travelers who had just crossed the bay via ferry and who did not like the crowded resort area.

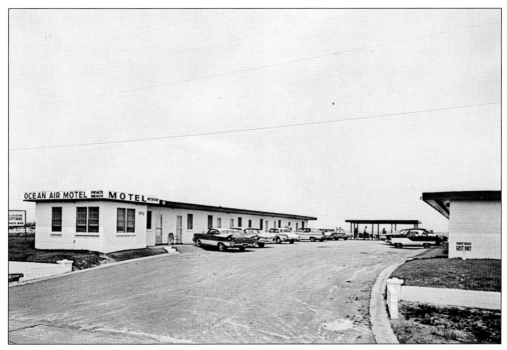

The Ocean Air was another motel on Page Avenue, just off Route 60 (Shore Drive). The motel offered fishing and swimming at its private beach. The motel was in business under one name or another for nearly 50 years.

RUDEE MOTEL APARTMENTS
RUDEE BOULEVARD - VIRGINIA BEACH, VA.
P. O. BOX 21 - PHONE: V. B. 684
TWO BLOCKS FROM ATLANTIC OCEAN

Both of these cards postmarked in the 1950s show what was considered modern for the time. The Hotel Prince Charles, located on Atlantic Avenue at Seventeenth Street, offered "Simmons Steel Furniture and Beautyrest mattresses in every room." The sign out front is for Sun's Chicken and Seafood, which would later become the Golden Dragon Restaurant.

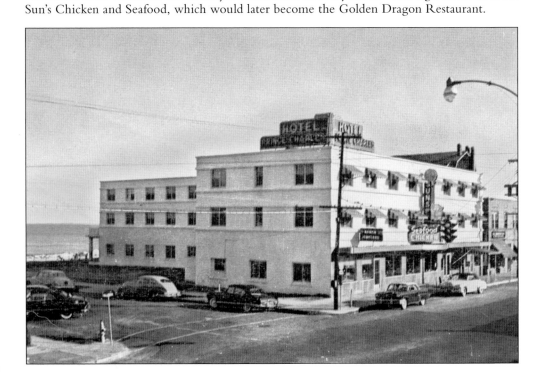

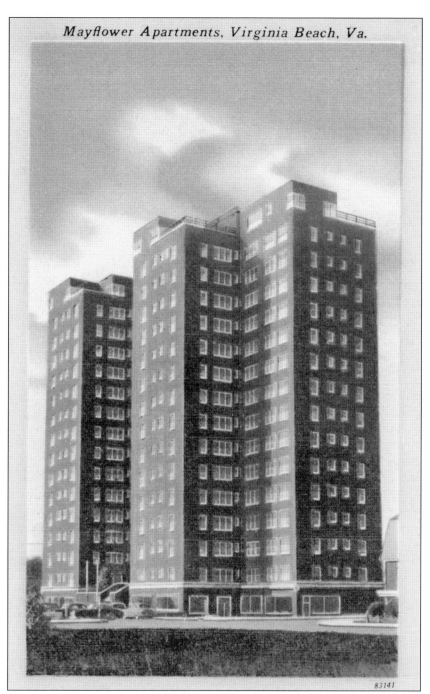

Mayflower Apartments, Virginia Beach, Va.

83141

The Mayflower Apartments were built at Thirty-fourth Street and Atlantic Avenue and opened in 1951. Shops and a restaurant occupied the first floor, and the 14 floors of apartments were topped by penthouses on the 16th floor. The Mayflower was the first high-rise building in Virginia Beach. It was, in fact, the tallest building in the state of Virginia when constructed. Today, the Mayflower looks basically the same as it did in 1951 and is still renting apartments with a terrific view of the ocean.

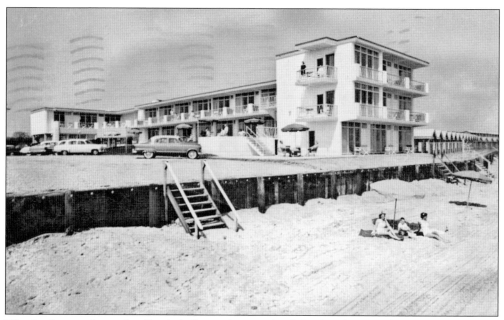

The Aeolus was located at Fortieth Street, just south of the Cavalier Beach Club cabanas. The motel advertised itself as a "tropical resort" and offered its guests a "sun, sip and snack patio." It was one of the first to be constructed with a full glass front in all rooms facing the ocean. This allowed guests an unobstructed view of the Atlantic.

The Holiday Sands was typical of the next generations of guest accommodations. Instead of returning to one place year after year, families' vacation habits changed: Virginia Beach one year, Miami the next, etc. Motels joined together under a common name. For example, Holiday Sands was a "Quality Court" motel.

Four

THINGS TO DO

Surf Bathing Is Fine, even the Dogs enjoy it, at VIRIGNIA BEACH, VA.

63348

Across the decades, there was always something to keep Virginia Beach visitors busy. When this card was mailed in 1936, nature still provided a wonderful way to have fun.

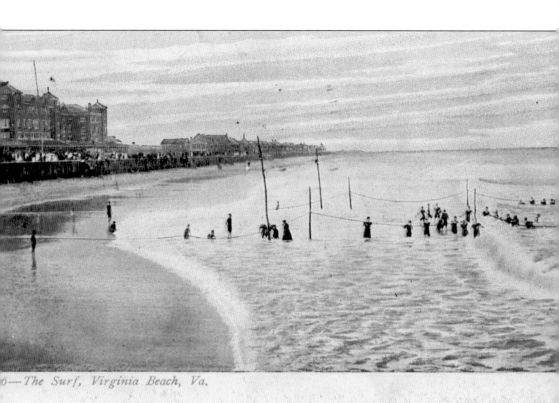

6—*The Surf, Virginia Beach, Va.*

This card, mailed in 1908, shows people "bathing" in the surf near the Princess Anne Hotel. Because women wore long, woolen dresses, even into the water, the ropes you see were literally "life lines." Without them, the ladies would have been pulled under and swept out to sea.

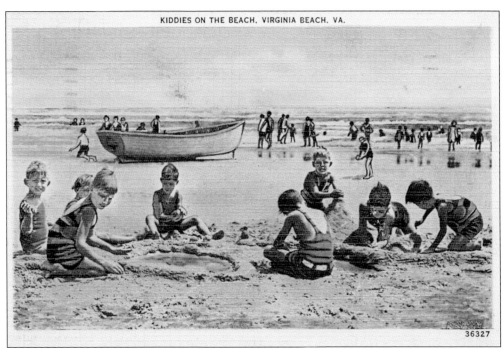

It only takes sand and water to keep children happy. A navy lieutenant commander sent this card home to his daughter on July 5, 1942. During the war, service personnel did not pay postage.

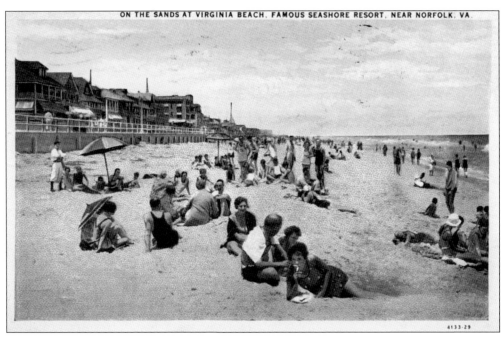

This card was sent from a little girl to her mother in 1930 and shows that grown-ups can have fun on the beach too. Notice the woman in the foreground smoking a cigarette.

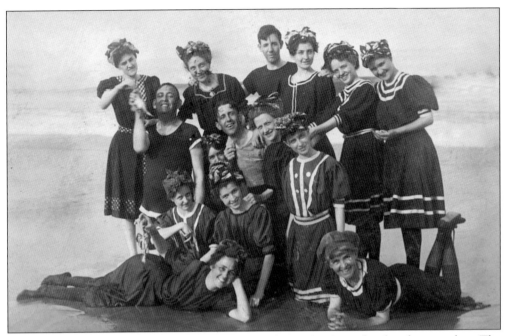

Also in 1908, these young men and women were hamming it up for the photographer. The card reads, "The Tennessee Bunch at the Beach. Wish you were here."

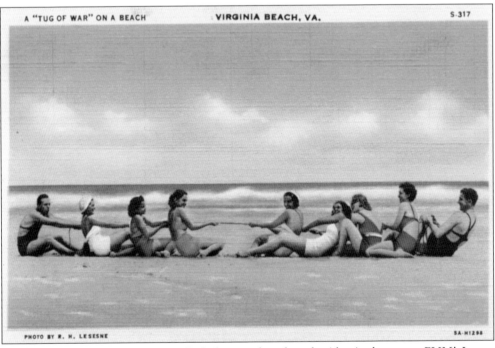

A "TUG OF WAR" ON A BEACH VIRGINIA BEACH, VA. S-317

PHOTO BY R. H. LESESNE 5A-H1298

The bathing suits of 1937 were a little less modest, but the idea is the same: FUN! It was common for publishers to print cards that showed no identifiable landmarks (like this one) and sell them generically. Different towns would stamp their own name onto the card. However, the girl writing the card does claim to be the "4th from the right."

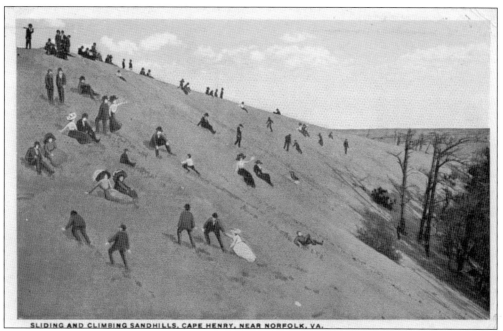

SLIDING AND CLIMBING SANDHILLS, CAPE HENRY, NEAR NORFOLK, VA.

Climbing the sand dunes, taking a look around, and then sliding to the bottom was considered great fun for visitors of all ages. In 1922, Ella wrote to her friend Pearl in Texas, "There's a lot of sand in Texas, but not like this."

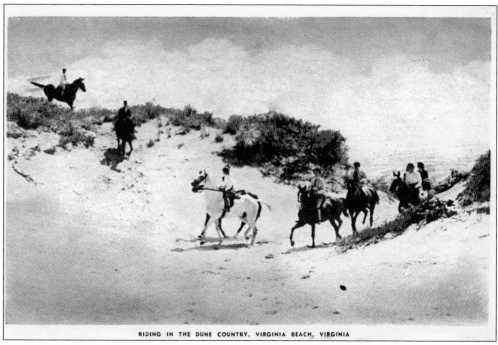

RIDING IN THE DUNE COUNTRY, VIRGINIA BEACH, VIRGINIA

Horseback riding through the dunes was an extremely popular activity in the late 1930s and early 1940s. During the war years, the military rode horses to patrol the beach for enemy saboteurs.

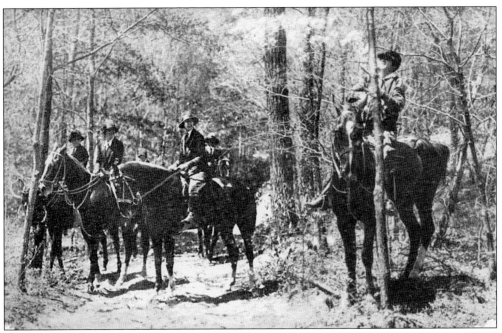

This card was one of several printed by the Ruth Murray Miller Advertisement Service as publicity for the Cavalier Hotel. The hotel had its own stable and horse ring, and it even offered fox hunting.

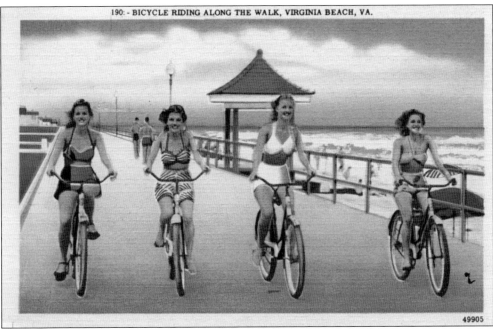

190: - BICYCLE RIDING ALONG THE WALK, VIRGINIA BEACH, VA.

49905

Of course, some people prefer bicycles to horses for the advantage of exercise. When the concrete boardwalk was built in 1927, it offered a good place to ride and afforded the opportunity to show off, as the girls in this undated card are doing.

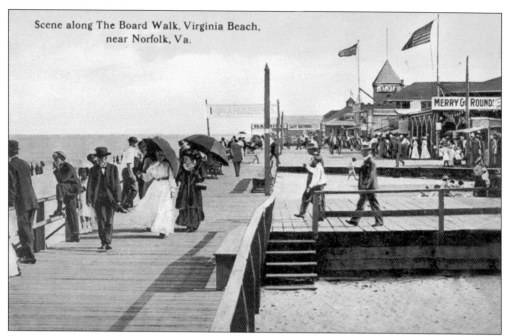

Scene along The Board Walk, Virginia Beach, near Norfolk, Va.

The boardwalk was also a perfect place for long, leisurely strolls, whether for exercise or simply for pleasure. Although 30 years separate these two cards (the top one dates 1910, the bottom one dates 1940), they are very similar in content. The boardwalk changed from wood to concrete, the parasols became beach umbrellas, and the hemlines went up just a bit, but in both scenes families enjoy their walks, and people lounge on the beach and swim in the surf.

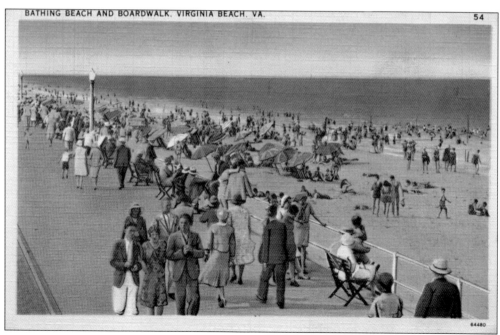

BATHING BEACH AND BOARDWALK, VIRGINIA BEACH, VA. 54

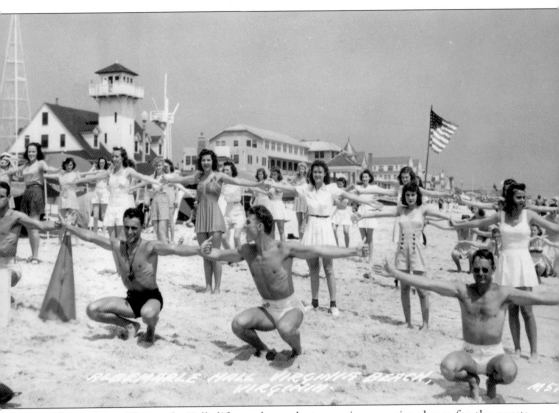

In front of the Albermarle Hall, lifeguards conduct morning exercise classes for the guests, although the only people in attendance are women. The Coast Guard Station, the Breakers Hotel, and the top of the turret at the Princess Anne Hotel on Twenty-fifth Street are visible in the background.

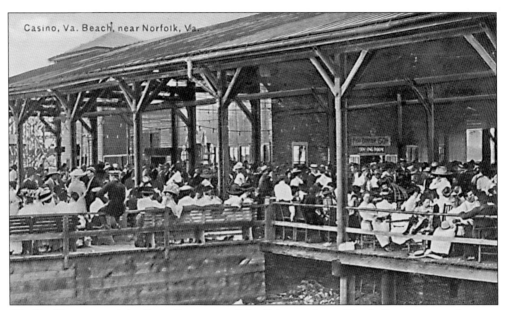

Casino, Va. Beach, near Norfolk, Va.

The Pavilion was originally built as part of the Princess Anne Hotel. So many people came to enjoy the food and the ocean breeze that the area around the hotel became too congested, and the Pavilion, called the Casino thereafter, was relocated to Tenth Street in 1903. As the picture proves, though, the place was no less popular in its new location. The sign over the dining room door advertises a fish dinner for 50¢.

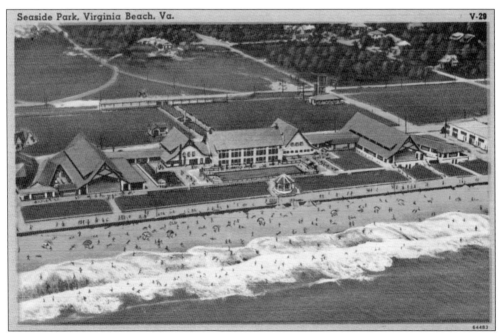

Seaside Park, Virginia Beach, Va. V-29

The Virginia Beach Casino, also known as Seaside Park, was built by the Norfolk Southern Railroad in 1906. In this aerial image, the Peacock Ballroom is visible on the left, the restaurant in the center, and the pool and bath house on the right. Seaside Park was located at the end of Thirty-first Street.

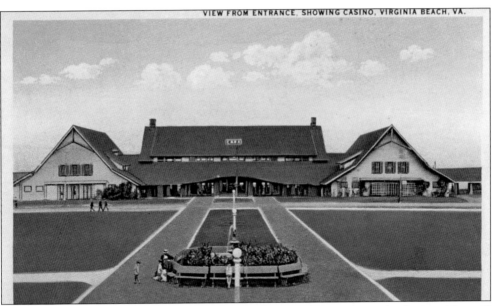

This view looking east from Pacific Avenue shows the main entrance to the Casino. The café is in the center, and the amusement centers are on either side. The Norfolk and Southern Railroad carried people to and from the Casino several times a day.

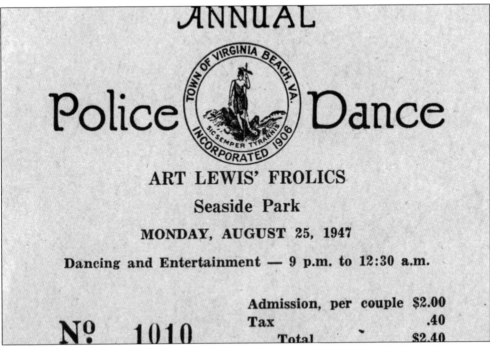

Art Lewis was a regular at the Peacock Ballroom at Seaside Park. In its heydays before the war, the Peacock featured band leaders like Cab Calloway, Tommy Dorsey, Duke Ellington, and Fats Waller entertaining crowds late into the summer nights. The trains that deposited and picked up passengers at the Thirty-second Street station were called the One-Step Special and the Two-Step Special.

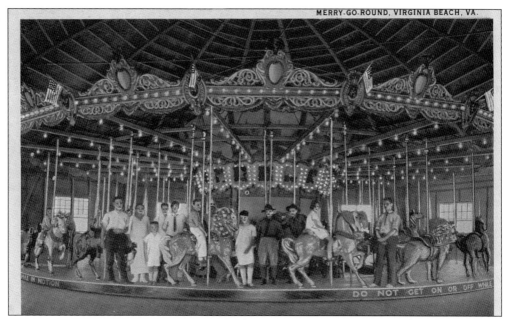

This merry-go-round was located in one of the amusement buildings at Seaside Park, probably the south building. There were two merry-go-rounds, but the one in the north building is described as being much more elaborate than this one.

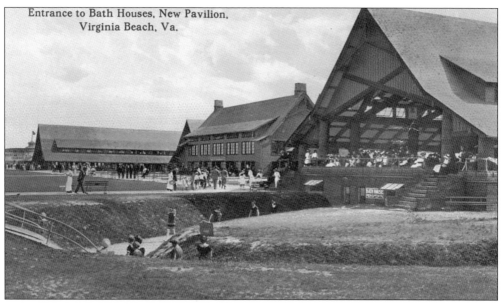

Entrance to Bath Houses, New Pavilion, Virginia Beach, Va.

This view facing southwest from the boardwalk shows Seaside Park. The sunken walkway passes under the wooden boardwalk and to the beach. At the bath house, visitors could rent swimming trunks for 25¢, shower, and change clothes. In 1925, a saltwater swimming pool was added. The Laskin brothers bought the park in the 1920s and constructed a concrete roadway from Norfolk to the front entrance. The road still bears their name, but the restaurant and concessions were destroyed by fire in 1934, the bath house was demolished in 1950, and a fire consumed the Casino in 1955.

This aerial view shows Atlantic Avenue facing south from Thirty-third Street. The vacant lot along the oceanfront was the location of Seaside Park Casino until the fire in October 1955. The octagonal building, about halfway up on the left, housed one of the two merry-go-rounds until it and all other remains of the great Seaside Park were demolished in the 1980s.

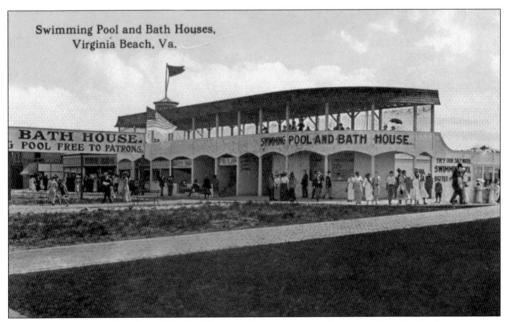

Grove's Swimming Pool and Bath House, though not as large as Seaside Park, was very popular, which may be a reason that the swimming pool was added to Seaside. Many people preferred the pool to the ocean because it provided saltwater without the waves or the sand.

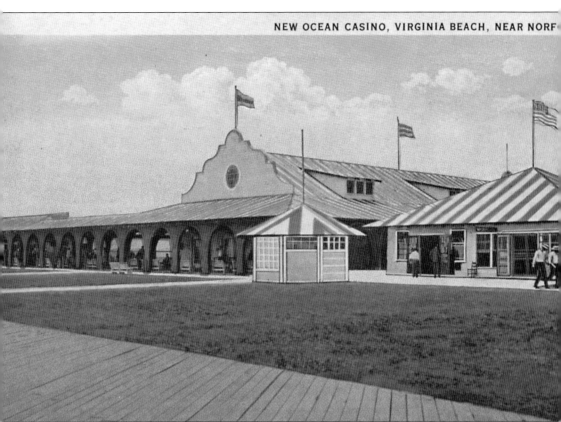

Following the great success of the Casino at Seaside Park, a competitor called the New Casino was built at Fifteenth Street. This postcard is undated, but it is known that the wooden boardwalk existed only until 1927.

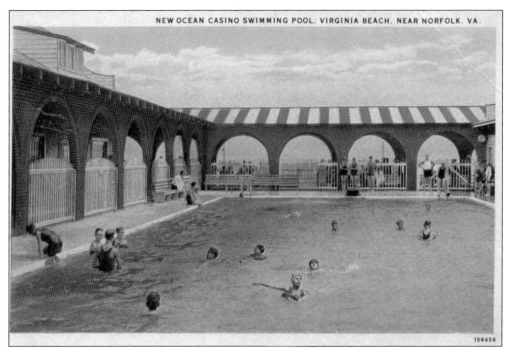

NEW OCEAN CASINO SWIMMING POOL, VIRGINIA BEACH, NEAR NORFOLK, VA.

106456

Two of the most popular attractions at the New Casino were the saltwater swimming pool and the dance hall. The dance hall was located in the north building and could be opened up to allow an open-air atmosphere while still providing shelter overhead.

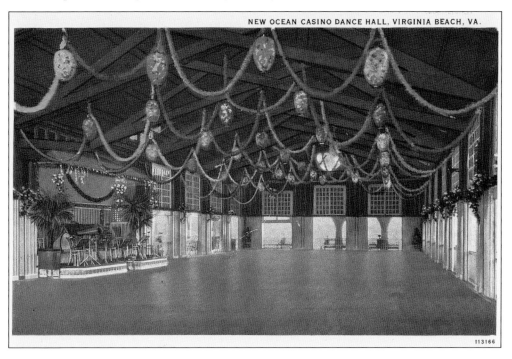

NEW OCEAN CASINO DANCE HALL, VIRGINIA BEACH, VA.

113166

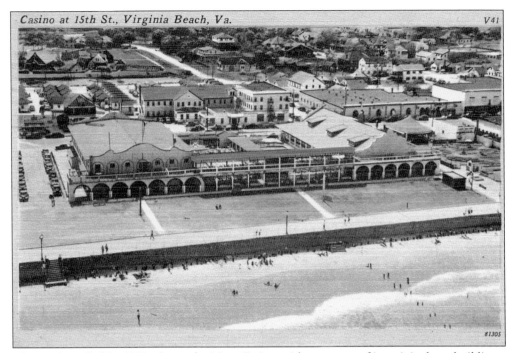

81305

This card, mailed in 1952, shows the New Casino without many of its original out buildings, such as gazebos, vendors, and ticket booths. The Tourist Haven Motel can be seen directly behind the Casino.

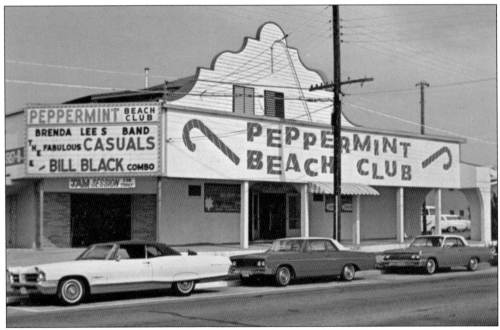

Like Seaside Park, the New Casino closed a little bit at a time. The dance hall, however, remained a popular club until the bitter end. With its easily recognizable, ornate facade, the New Casino Dance Hall lived on as the Peppermint Beach Club until the 1990s.

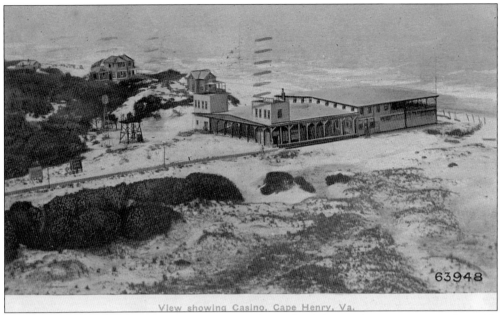

View showing Casino, Cape Henry, Va.

O'Keefe's Casino opened at Cape Henry in the early 1900s and was very popular with conventioneers who were brought in by train from Norfolk. In November 1909, the National Inland Waterways Association and the guest speaker, President William Howard Taft, attended an oyster roast at O'Keefe's.

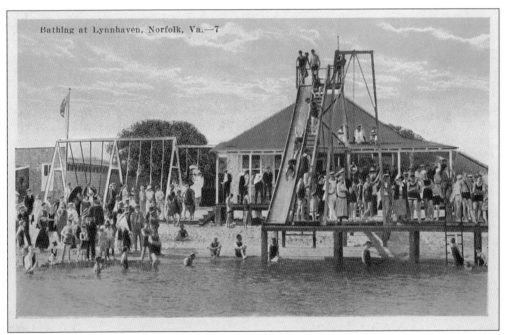

Bathing at Lynnhaven, Norfolk, Va.—7

There were also casinos at Seaview Beach, Ocean Park, and Chesapeake Beach. This card shows part of the Ocean Park Casino complex. The bath house is visible on the left, and in the center, behind the slide, is the "Shell House," whose walls were made of oyster shells set in concrete. The Saunders Hotel is not shown.

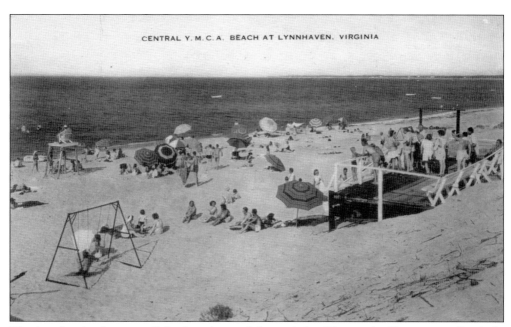

CENTRAL Y. M. C. A. BEACH AT LYNNHAVEN, VIRGINIA

The beaches in the area of the Lynnhaven Inlet and the Chesapeake Bay were collectively referred to as Lynnhaven Beach. On the east side of the inlet, near the Ocean Park Casino, was the Central YMCA beach, seen here.

Y. W. C. A. CAMP OWAISA, Chesapeake Beach, Norfolk, Va.

On the west side of Lynnhaven Inlet was the YWCA camp. In 1918, a summer program at Broad Bay Farm took root when Mr. John B. Dey donated the use of property to allow 25 girls the experience of camping, crabbing, fishing, and boating. In 1922, when this card was mailed, the Girl's Work Committee purchased property at Chesapeake Beach and established Camp Owasia (a Native American name meaning "camp of happiness").

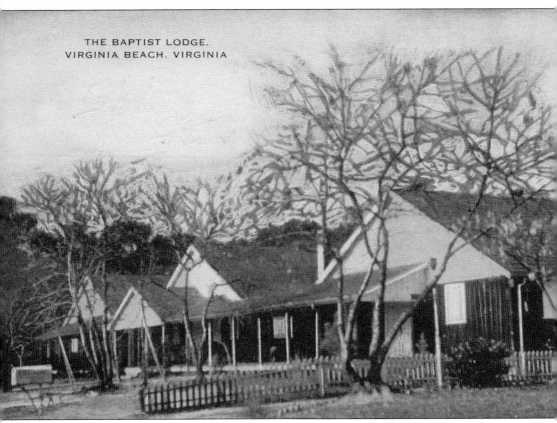

THE BAPTIST LODGE.
VIRGINIA BEACH. VIRGINIA

The Baptist Lodge, located on 129th Street (now 89th Street) at the extreme north end of Atlantic Avenue, was the location of a summer recreational camp for teens. Youngsters lined up single file outside of the dining room three times a day, and the local residents could tell how many were present by counting the number of times the screen door slammed shut.

Four enterprising young men found a way to make a profit when this 60-foot whale washed up on the north beach at Cape Henry. The men roped off the area and charged visitors 10¢ to see the corpse. This picture postcard was also available for sale. The dead leviathan was so popular that the train made a special "Whale Station" stop, which helped the partners earn $87 each for their creativity.

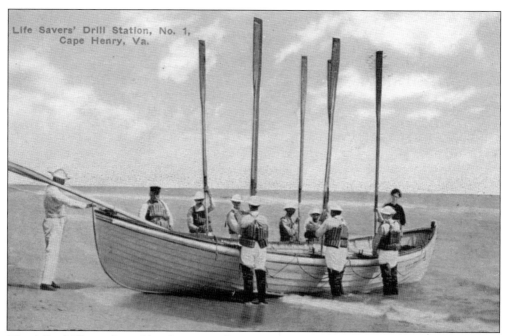

The daily drills conducted by the U.S. Life-Saving Service were very popular attractions at all four stations. The well-choreographed movements and the repetitive training insured that the surfmen could do their job under the most extreme circumstances.

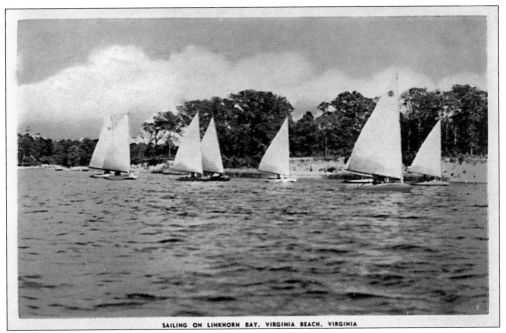

SAILING ON LINKHORN BAY, VIRGINIA BEACH, VIRGINIA

The water provided many forms of entertainment. Boats of various sizes and types were available for rent, and this card shows what seems to be a regatta. The Cavalier Yacht and Country Club sponsored several each year.

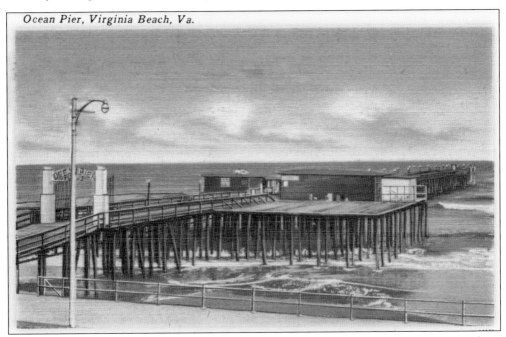

Ocean Pier, Virginia Beach, Va.

For those who preferred fishing, the Ocean Pier was built in 1940 at Fifteenth Street in front of the New Casino. It later became known as the "wooden pier" to distinguish it from one built of steel a few blocks to the south. Strangely, the steel pier is gone, but the wooden pier still stands.

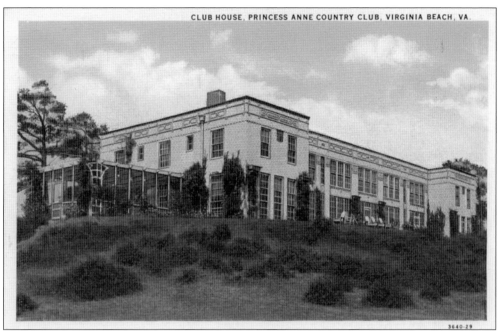

CLUB HOUSE, PRINCESS ANNE COUNTRY CLUB, VIRGINIA BEACH, VA.

There were two excellent courses for golfers. The first was the Princess Anne Country Club at Thirty-eighth Street and Pacific Avenue. When the Cavalier Hotel opened in 1927, arrangements were made for the guests to use the golf course. Then, the Cavalier designed and built its own golf course a few miles away at the end of Birdneck Road. "The holes were modeled after famous holes at famous golf courses . . . and the links are almost entirely surrounded by water." Although it later became the Cavalier Yacht and Country Club, those are not boat docks seen in the aerial picture but platforms for shooting skeet.

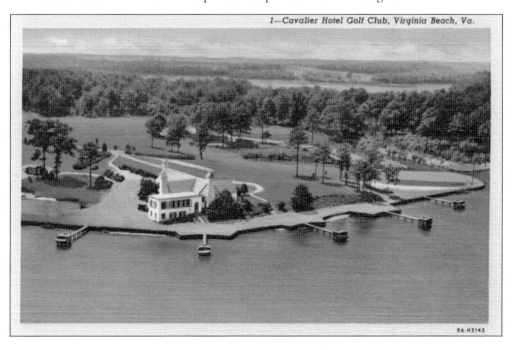

1—Cavalier Hotel Golf Club, Virginia Beach, Va.

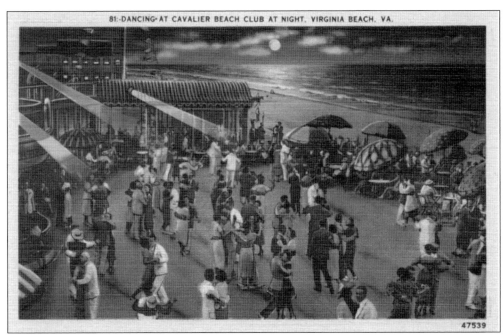

81.-DANCING AT CAVALIER BEACH CLUB AT NIGHT, VIRGINIA BEACH, VA.

47539

Not everyone who came to Virginia Beach was on vacation. Many people came from nearby cities just for a night of dancing at one of the fabulous clubs. The club that set the standard for all others was the Cavalier Beach Club. Open-air dances were held every night except Sunday, Memorial Day through Labor Day (weather permitting). Afternoon, or teatime, dances were especially popular on Sundays.

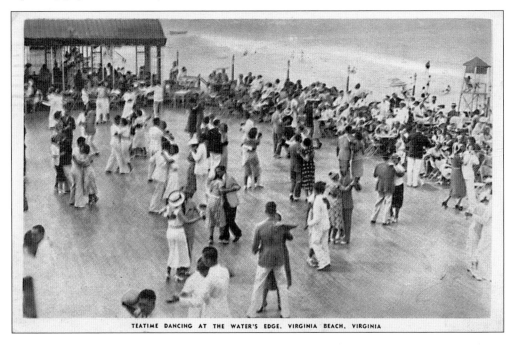

TEATIME DANCING AT THE WATER'S EDGE, VIRGINIA BEACH, VIRGINIA

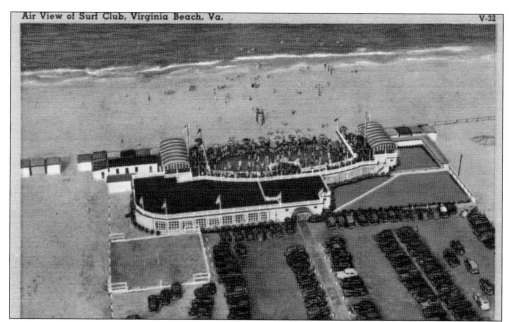

When the Surf Club opened on Memorial Day weekend in 1936, 800 members and guests attended. The club's location, Fifty-seventh Street at the oceanfront, put it very close to the Cavalier, and many people had memberships to both clubs. Louie Prima and his band traditionally ended each summer season by playing "When the Saints Go Marching In" to a crowd that overflowed onto the beach. While playing, the band marched off stage, onto the beach, and into the surf.

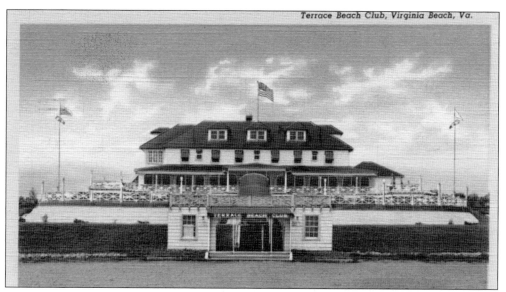

Terrace Beach Club, Virginia Beach, Va.

The Terrace Beach Club, formed early in 1938, bought the Princess Pat Hotel at Sixty-seventh Street and Atlantic Avenue. By April, an outdoor (concrete) dance floor was installed. Soon after, the club opened to the public. The building might look familiar: in 1927, it was built as a holistic hospital by psychic Edgar Cayce. When the hospital failed in the early 1930s, the building was sold and became the Pat Hotel. The Cayce family bought the building back in the 1950s.

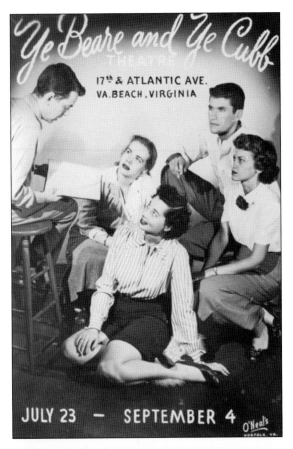

17ᵗʰ & ATLANTIC AVE.
VA.BEACH, VIRGINIA

JULY 23 — SEPTEMBER 4

For those seeking more refined entertainment, there was everything from avant-garde theatre to open-air symphonic drama. The card at the left advertises Ye Beare and Ye Cubb Theatre. This group took its name from the first professional theatre troupe in the Virginia Colonies and produced shows in the old Roland Theatre Building at Seventeenth Street and Atlantic Avenue. They closed after their first year. The card below is a scene from the dramatic musical *The Confederacy*. The show was written by Pulitzer Prize–winner Paul Green and performed by the Tidewater Historic Dramatic Association at the Robert E. Lee Amphitheatre on Twenty-fourth Street. The show closed in 1959 after two summer seasons.

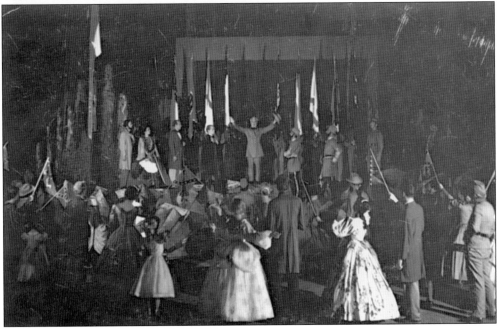

In spite of the growing population of Virginia Beach and the surrounding Princess Anne County, it was still possible to be alone in the midst of the area's natural beauty. When plans were made to subdivide the historic great sand "desert," the Cape Henry Syndicate deeded 1,000 acres of the property to the State of Virginia in 1933 to protect it from development. This inspired the State to purchase an additional 2,375 acres in 1938. Thus, Seashore State Park was born, one of six parks operated by the Virginia Conservation Commission (VCC). The park provides swimming, cabins for rent, and miles of nature trails. The card to the right was published by the VCC and distributed as an advertisement. The park recently changed its name to First Landing State Park. The writer of the bottom card mentions that on July 10, 1949, the temperature was "about 90 degrees," which shows that some things don't change.

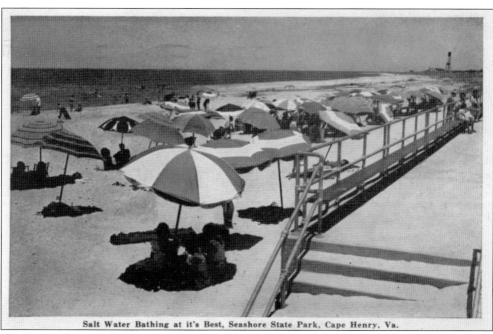

Salt Water Bathing at it's Best, Seashore State Park, Cape Henry, Va.

Delhaven Gardens occupied 30 acres in the Bayside community of Princess Anne County along the Lynnhaven River. Although privately owned, admission to the garden was free to the public and showcased 80,000 azaleas, along with dogwoods, hollies, and loblolly pines. There were shaded picnic areas, boat rentals, and a plant nursery.

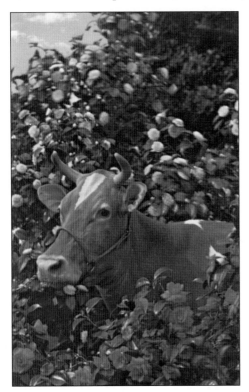

Bayville Farms was another attraction in Bayside. The dairy was the largest producer and distributor of Golden Guernsey milk in the United States and provided breeding stock on an international level. This card introduces "Lady of the Camellias," a famous Guernsey who resided at the farm. Bayville Farm was established in 1828 and was in operation until the 1980s. It is now a privately owned golf club.

Five

PLACES TO EAT

The Duck-In Restaurant started in 1952 as a small roadside diner and carry-out store on the shoulder of Shore Drive, next to the old Lesner Bridge and train trestle. It earned its name because it was so small you had to "duck in" and "duck out" through the front door. When the concrete bridge was built in 1958, the restaurant was moved a few hundred yards and placed on pilings at its present location.

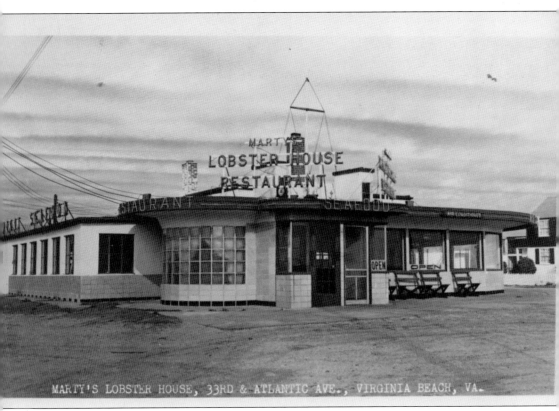

Marty's Lobster House had an excellent location on the northeast corner of Thirty-third Street and Atlantic Avenue, directly across from Seaside Park. The restaurant specialized in chicken, Kansas City steaks, and, of course, lobster.

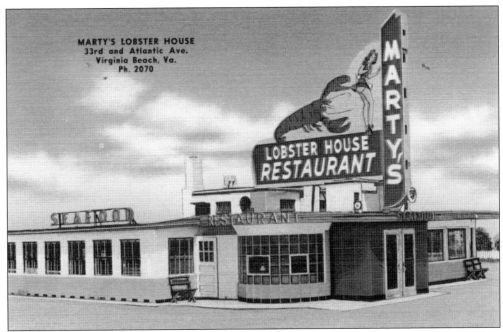

MARTY'S LOBSTER HOUSE
33rd and Atlantic Ave.
Virginia Beach, Va.
Ph. 2070

When people talked about Marty's in the early 1950s, it wasn't just because of the good food. A risqué sign showing a waitress's skirt being lifted by a giant lobster was great advertisement for the restaurant. In 1959, a similar image appeared nationwide promoting Coppertone Suntan Lotion. (Remember the little girl saying, "Don't be a paleface"?) As demonstrated by the other card, Marty's sign and his restaurant had undergone some minor changes by the end of the decade. Too bad the prices had to change, too: in 1955, a two-pound lobster was $4.50.

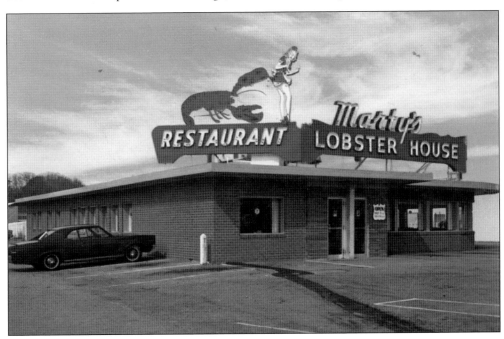

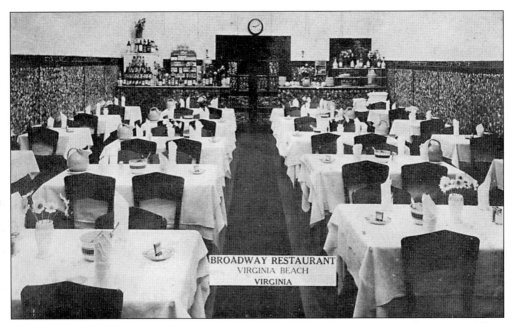

This card was a not-very-good advertisement for the Broadway Restaurant: there is no address other than Virginia Beach, Virginia, printed on the card. The restaurant opened in the 1940s and operated for 20 years on Atlantic Avenue near Seventeenth Street.

The Lynnhaven Inn-Let Restaurant was located on Route 60 (Shore Drive), near the Lesner Bridge. This card appears to be from the late 1930s. The restaurant's motto was, "People come and people go, the food from here is fresh you know."

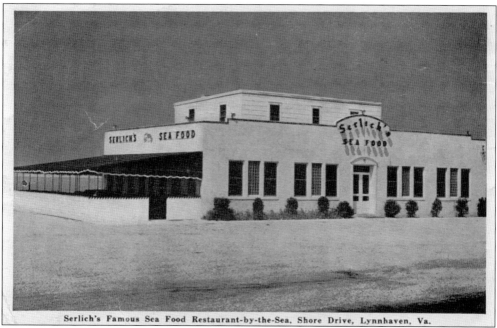

Serlich's Famous Sea Food Restaurant-by-the-Sea, Shore Drive, Lynnhaven, Va.

Serlich's Sea Food Restaurant, shown here in 1949, was located on the north side of Shore Drive, at the west end of the Lesner Bridge, and was large enough to accommodate 300 people. About a mile away, where Great Neck Road crossed Long Creek, Dutch's Seven Seas Restaurant operated in an old house boat. Dutch's closed in the early 1950s. Serlich's name was changed to "7 Seas" in 1963, about 10 years before the building was razed to make room for a high-rise condo.

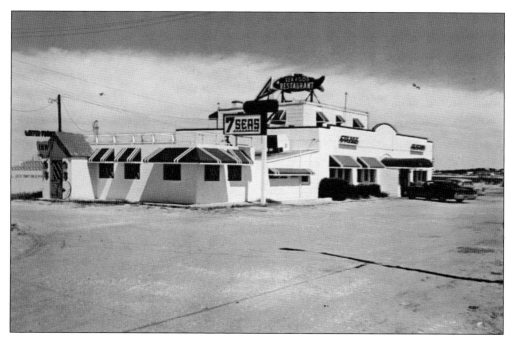

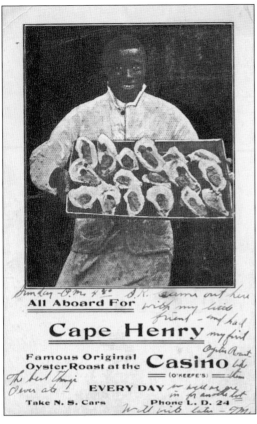

All Aboard For

Cape Henry

Famous Original
Oyster Roast at the **Casino**
=== (O'KEEFE'S) ===

EVERY DAY

Take N. S. Cars Phone L. D. 24

Almost every eatery in the area served Lynnhaven oysters, but it was O'Keefe's Restaurant and Casino that made them famous. In 1909, President William Howard Taft visited O'Keefe's and tried the local delicacy for the first time. He liked them so much that he ate his fill, and as he was a rather large man, his "fill" was several dozen. After his return to Washington, he occasionally had Lynnhaven oysters delivered to him at the White House, and he spoke so highly of them that they received national recognition. The card to the left, postmarked April 1913, shows that in those days, the oysters were much larger than what we're used to today.

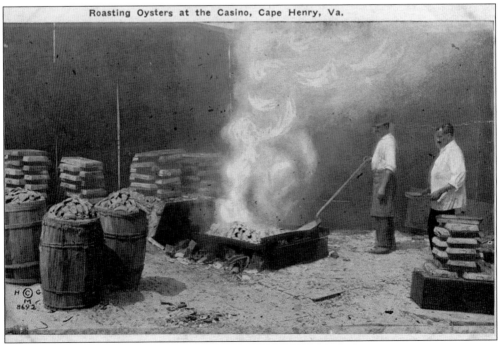

Roasting Oysters at the Casino, Cape Henry, Va.

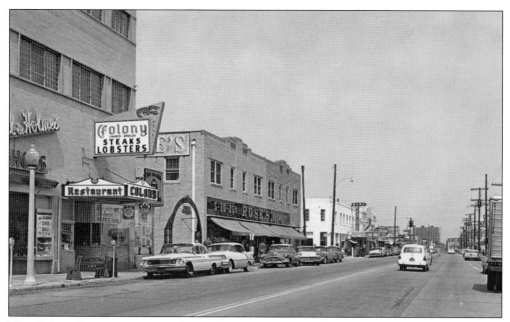

The Colony Restaurant operated on Atlantic near Nineteenth Street from the late 1940s into the 1950s. In 1949, the Colony was the only restaurant in Virginia Beach approved by the American Restaurant Association. As the establishment faced the street and not the ocean, the owner had to rely on the food, not the view, to entice his customers. This card shows the Colony's location next to Russell & Holmes Shoes in the Jefferson Hotel building.

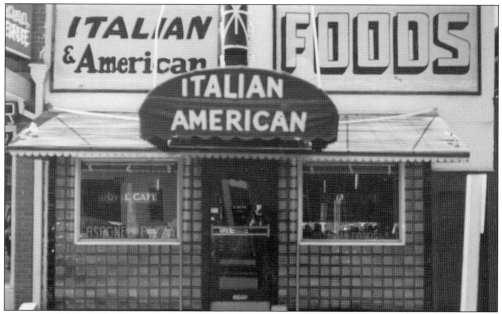

Another post–World War II restaurant was Teddy's Royal Café Restaurant, located at 2102 1/2 Atlantic Avenue. It is apparent in the postcard that Teddy's had very little to offer except good food. With all the other restaurants offering "the best seafood," Teddy's went after a different market. Seafood was on the menu, of course, but the specialty of the house was Italian.

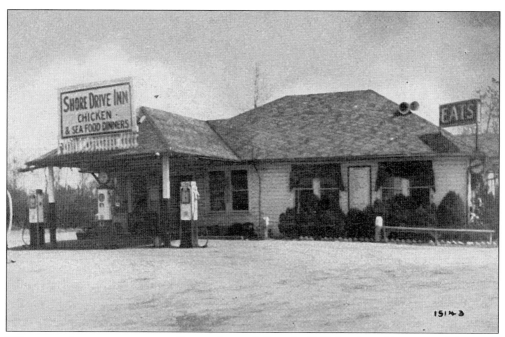

What started out as a corner gasoline station and diner in 1941 developed into one of the area's most memorable restaurants. Located at the intersection of Highways 60 and 460 (Shore Drive and Pleasure House Road), the Shore Drive Inn was not far from the Chesapeake Beach Casino and the Hope Hotel. Owned and operated by Mr. W.W. Oliver, the early restaurant offered "chicken and seafood dinners." After extensive renovation in the early 1950s, the atmosphere changed and so did the menu, now specializing in filet mignon. For the next 40 years, the Shore Drive Inn was a favorite place to celebrate special occasions or just to enjoy a relaxed dinner out.

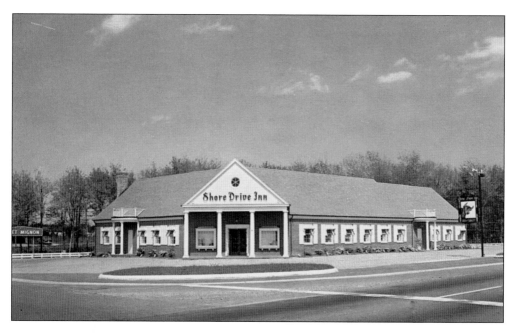

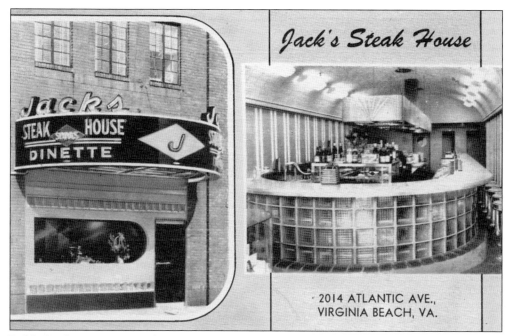

Jack's Steak House, on Atlantic Avenue near Twentieth Street, offered counter service in addition to tables and booths. The marquee out front demanded attention, and the color and design of the front entrance were inviting. With stools, an arched ceiling, polished chrome, and an open kitchen, Jack's was a classic 1950s dinette.

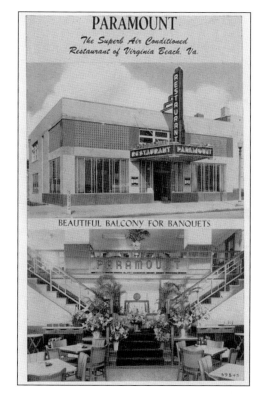

The Paramount Restaurant also had an art deco style. Located on the corner of Eighteenth Street and Atlantic Avenue, the Paramount offered two levels of dining. In addition to steaks and seafood, there were also "regular meals" on the menu.

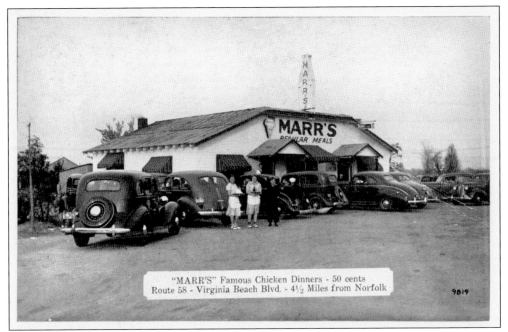

"MARR'S" Famous Chicken Dinners - 50 cents
Route 58 - Virginia Beach Blvd. - 4½ Miles from Norfolk

9819

Opened in the 1930s, Marr's Restaurant was perhaps one of the first drive-in restaurants in the area. Situated on Virginia Beach Boulevard, east of Witchduck Road, it was part of Marr's Dairy and was a popular stop for travelers going between Norfolk and Virginia Beach. The waitresses at Marr's would bring orders out on trays, and customers could eat in their cars.

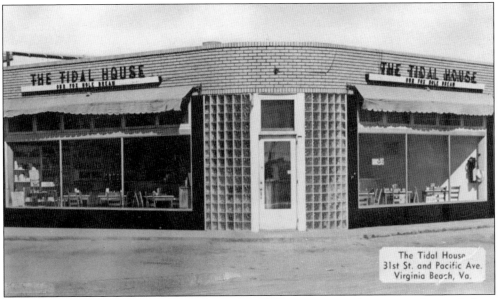

The Tidal House
31st St. and Pacific Ave.
Virginia Beach, Va.

The sign reads "The Tidal House," but under that, in much smaller letters, are the words "our fox hole dream." Two local men, who served in Europe during World War II, waited out an enemy bombardment in a shell crater or "fox hole." They decided then that if they both survived, they would open a restaurant when they got back home. The restaurant at the corner of Thirty-first Street and Pacific Avenue is evidence that both men made it home alive.

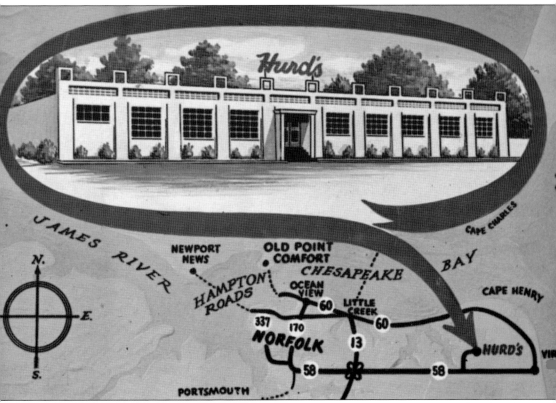

Hurd's restaurant opened in 1936 as a small diner on the Lynnhaven River, but by the 1950s when this card was printed, it had grown to accommodate 240 patrons. Because of its obscure location, most advertisements for the restaurant included a map. The food at Hurd's was cooked in peanut oil long before the nation was concerned about the health hazards of food fried in animal fat. The restaurant remained a popular place to dine until it was destroyed by fire in the 1970s.

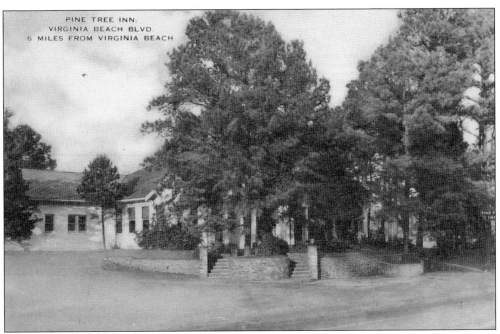

Above is a photo postcard published in June 1948 showing the Pine Tree Inn restaurant. The bottom card was published that same year from that same image, but an artist modified it to reveal more of the building. Located 10 miles from Norfolk and 6 miles from the oceanfront, the Pine Tree Inn was open from noon to 10:00 every day of the year. The restaurant offered "Fried Chicken and Virginia Ham, Blackeye peas and Candied Yam" and was proud to be a Betty Crocker recommended establishment. The restaurant opened in 1927 and was in business for nearly 70 years.

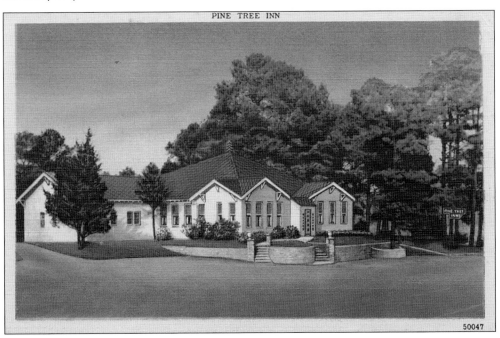

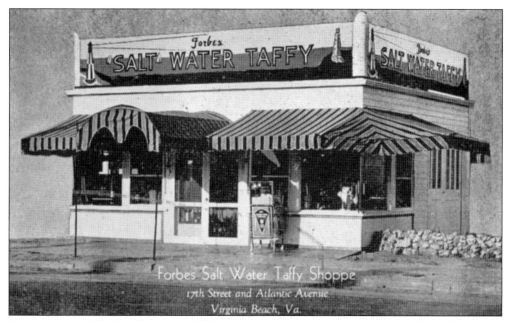

Forbes Salt Water Taffy Shoppe
17th Street and Atlantic Avenue
Virginia Beach, Va.

No vacation to Virginia Beach would be complete without some saltwater taffy; Forbes began making and selling it in 1933. The first store was at Twenty-first Street and Atlantic Avenue. The second outlet, seen in the top card, was located at Seventeenth Street and Atlantic Avenue. The bottom card shows the shop at Twenty-second Street and Atlantic Avenue. The Forbes family has now added a huge, wholesale candy factory to its operations.

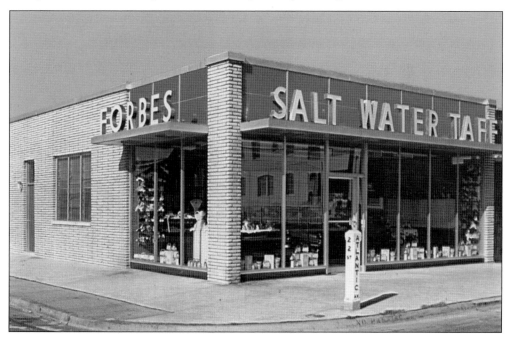

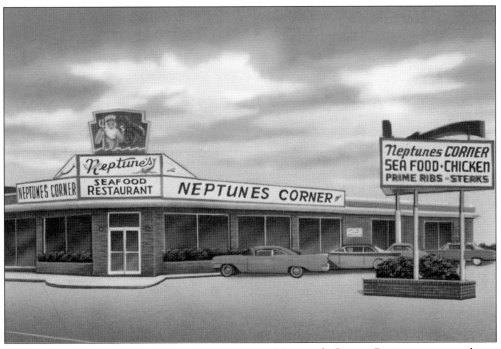

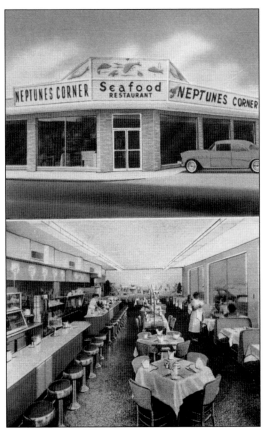

Neptune's Corner Restaurant opened in 1954 at the intersection of Laskin Road (Thirty-first Street) and Atlantic Avenue, two of the busiest streets at the oceanfront. Seaside Park was across the street, stretching from Thirtieth Street to Thirty-third Street, and even the fire that destroyed the Casino portion of the park didn't hurt business at the new diner. Like Marty's a few blocks away, the sign changed a few times over the years, but the restaurant's popularity and good food did not. Just one year shy of its 50th anniversary, Neptune's Corner was flattened to make room for a parking garage.

Six

THE MILITARY

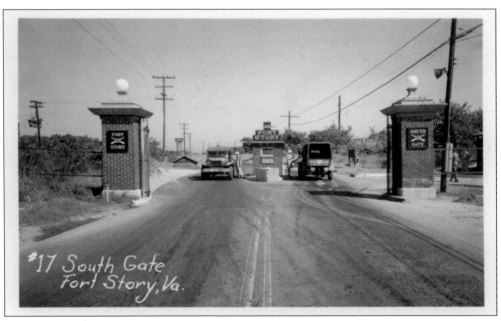

This picture, taken shortly after the end of World War II, shows the South Gate (now the Main Gate) of Fort Story at Cape Henry. There are also military installations at Little Creek, Camp Pendleton, and Oceana. The military presence has had a great influence in the growth of the city.

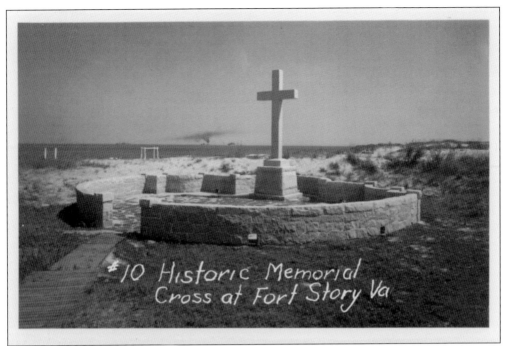

#10 Historic Memorial Cross at Fort Story Va

Usually, thoughts conjured about Cape Henry are of early English settlers or of relaxing sunbathers. However, during wartimes, the cape connotes a different significance. In 1914, the Virginia General Assembly turned over nearly 345 acres of pristine, oceanfront property to the federal government. The area became the Coast Defenses of the Chesapeake Bay and was named Fort Story after a general in the coast artillery prior to the turn of the century.

#24 Beach Scene at Fort Story

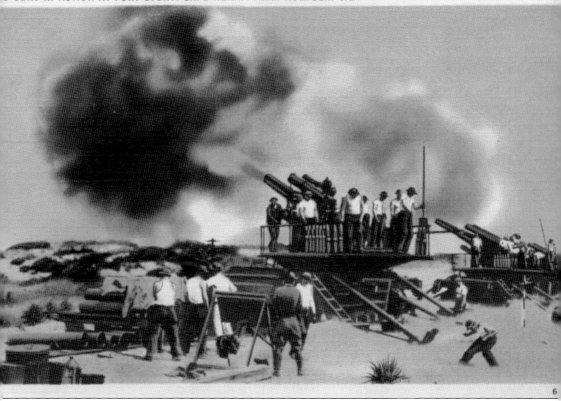

6

Following the War of 1812, during which British forces burned our nation's capital, the U.S. military vowed enemy warships would never again enter the Chesapeake Bay. The primary purpose of Fort Story was to ensure this. In May 1928, the 52nd Coast Artillery put on a public demonstration by firing the fort's big guns. This card shows the 8-inch railway guns in operation. The guns were silent for the next 13 years.

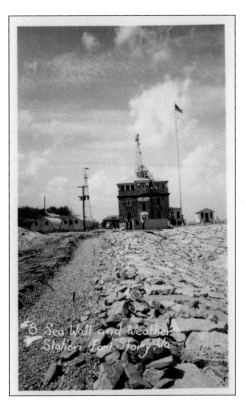

In 1917, the U.S. Weather Bureau Station at Cape Henry became the Harbor Defense Command Post and USN Signal Station for the duration of the war. It resumed in that capacity in 1938 as America braced itself for the anticipated war in Europe.

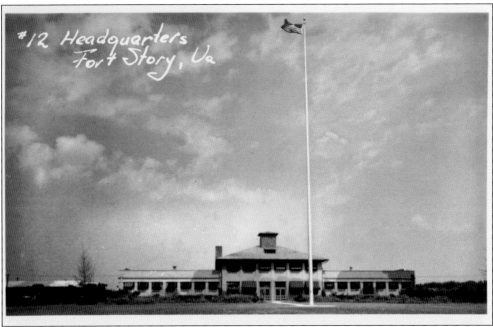

This building was constructed to serve as the post headquarters in 1917 and still serves that function today. Taken after the war, with the parade ground in the foreground, this photograph shows the building with its camouflage paint scheme.

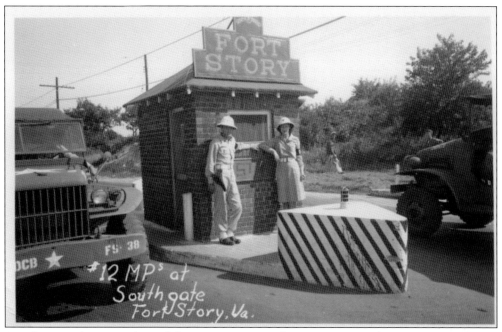

No photographs were taken of the construction and preparations made at Fort Story during the war, partly because everything happened so quickly and haphazardly but also because the arrangements were considered classified. After the war, a series of photos were taken and made into postcards showing life on the post during the war. Here are the two of the three entrances into Fort Story. The letters "HDCB" on the front of the truck stand for Harbor Defense of Chesapeake Bay. An obvious clue dates this photo: women did not do guard duty during the war.

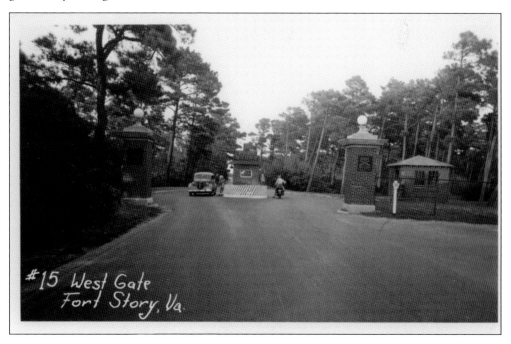

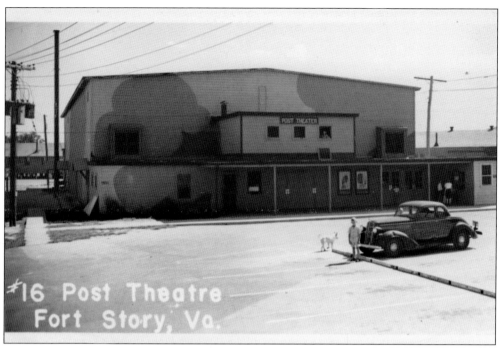

#16 Post Theatre Fort Story, Va.

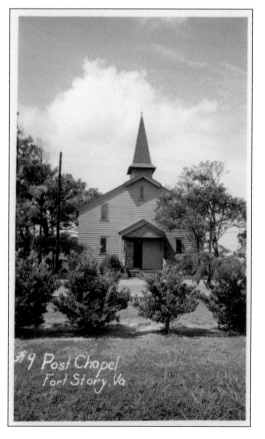

#9 Post Chapel Fort Story, Va.

While the soldiers trained and waited for the fight that could come at any time, they needed ways to relax, to ease their minds, and to comfort their souls. The post theatre was built in 1941 and is shown above with its wartime camouflage. It was torn down in the 1980s. The interfaith chapel (left) was constructed in 1942 and demolished in the 1990s.

#23 Hospital Circle
Fort STory, Va.

Because a German invasion seemed not only possible but very likely, the army anticipated casualties. The U.S. Army Field Hospital in Fort Story, Virginia, was built in January 1941. As the war progressed and victories were won, the troops at Fort Story were taken from their defensive posture and sent overseas to go on the offense. In September 1944, the field hospital was converted to a convalescent hospital for soldiers returning from European operations. The hospital served as a limited-stay facility for men suffering from shell shock or battle fatigue (what we now refer to as post-traumatic stress syndrome). The 1,800-bed facility was closed in March 1946 after caring for more than 13,000 war-weary veterans.

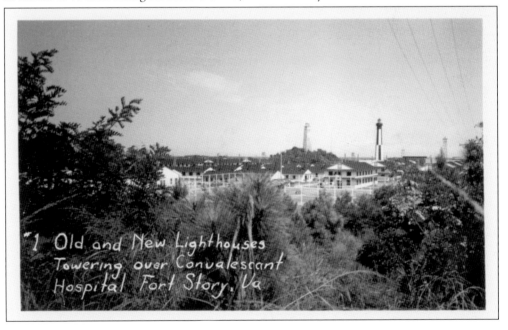

"1 Old and New Lighthouses
Towering over Convalescant
Hospital Fort Story, Va

Town Ordinance Regarding Blackout

In compliance with the Town Ordinance that the entire ocean front be blacked out at night, black curtains have been put up in each room for this purpose. These must be drawn each night before lights are turned on and kept closed until lights are out. The occupants of each room are entirely responsible, and anyone failing to comply with this ordinance will be liable to a fine.

THE POLICE DEPARTMENT.
C. E. HOBECK, Chief of Police.

In 1942, with German U-boats wreaking havoc off the Virginia coast, a blackout was ordered along the oceanfront as well as the bay front. These cards were placed in all hotel rooms with a water view. The blackout curtains were installed by the hotel management, but it was each guest's responsibility to keep the curtains closed if there was a light on in the room. Blackout "wardens" patrolled the beaches and streets to ensure compliance.

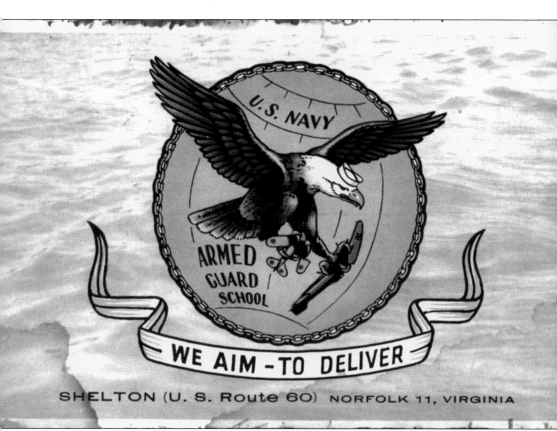

U.S. NAVY

ARMED GUARD SCHOOL

WE AIM - TO DELIVER

SHELTON (U. S. Route 60) NORFOLK 11, VIRGINIA

On June 15, 1942, the Whitehurst Farm, off Shore Drive, was mostly just beanfields. By the end of the month, after the navy constructed four bases in the area, the farm was the center of activity. These bases joined the U.S. Army mine bases that were built the previous year. Two of the camps, Camp Shelton and Camp Bradford, were named for previous owners of the land. Camp Shelton was an armed guard training center for the bluejackets who served on board merchant ships and manned the guns should there be an attack by an enemy submarine or aircraft.

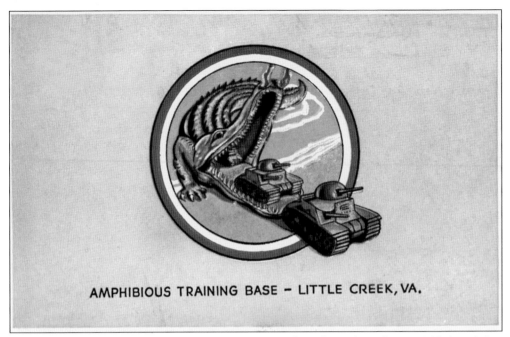

AMPHIBIOUS TRAINING BASE - LITTLE CREEK, VA.

Camp Bradford was originally designated as a training base for Seabees, but in 1943, its mission changed to the development and training of amphibious assault tactics and its name changed to Amphibious Training Base (ATB).

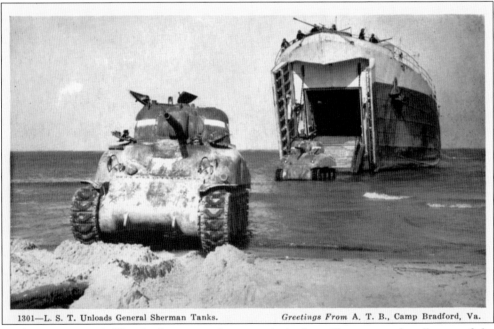

1301—L. S. T. Unloads General Sherman Tanks. *Greetings From* A. T. B., Camp Bradford, Va.

Looking very much like the image on the camp insignia, a Sherman tank rolls out of the mouth of a landing ship tank (LST). Other units that were used for training were landing craft utility (LCU), landing craft mechanized (LCM), landing craft personnel (LCP), landing craft vehicle (LCV), and landing craft infantry (LCI).

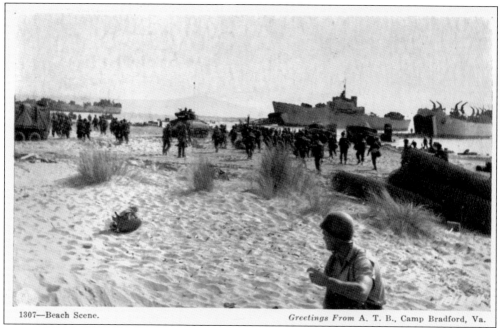

1307—Beach Scene. *Greetings From A. T. B., Camp Bradford, Va.*

This is one of several exercises used as training for an actual combat landing. The men of AMB, Little Creek, or simply "Little Creek," first saw action in the Pacific as part of the assault on the beaches of Leyte in the Phillipines.

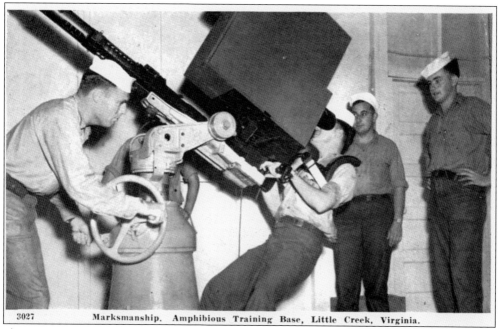

3027 Marksmanship. Amphibious Training Base, Little Creek, Virginia.

Getting the soldiers onto the beach was only part of an amphibious landing. It was also essential to protect the men, the ships, and the landing craft from enemy aircraft. In this scene, a sailor uses a simulator to learn how to fire an anti-aircraft gun.

The war not only changed the face of America, but it also changed the appearance of postcards. As a tribute to the men and women serving in the armed services, military personnel were not required to use postage when mailing a card or letter. They merely had to put the word "free" where the stamp would go and include their name, branch of service, and assignment. This saved them the time and expense of getting stamps and encouraged correspondence with the people back home. In the civilian world, patriotic stamps became common, and postmarks reminded us to "Buy war savings bonds and stamps."

Seven

SOUVENIRS

These two unidentified girls had their picture taken as a souvenir in 1914. The card is stamped "Virginia Beach Casino, Postal Studios, Virginia Beach, VA." The girls are sitting on real sand, but the ocean and the Casino is a backdrop. Not all souvenir cards were custom made.

This card was mailed to Floyd, Virginia, in June of 1940. The following quotes are from similar postcards: "We are here at the beach having a wonderful time. Wish you were here with us. The Ocean is grand." "I guess I will go out for a sun bath later this p.m. You should be here. Plenty of hot weather." "8/17/50, A delightful place here and much of interest. We are having a nice vacation." "March 29, 1943, Dear Grandma, We thought we would have a good time sun bathing but the weather is so bad we can't go out." "Just got out of the water. Ready for a drink. Ann."

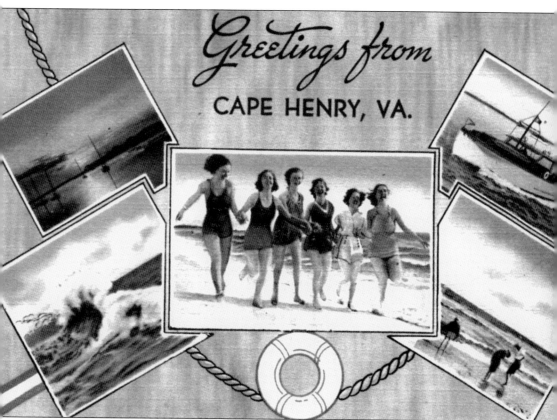

Greetings from CAPE HENRY, VA.

None of these images are actually of Cape Henry. Cards like this were purchased by merchants around the country who then added their specific town name. These comments could refer to any beach. "I am having a wonderful time playing on the beach all day and watching television at night. Wish you were here to enjoy it with me." "Dear Folks, We made the trip fine & today is truly a rainy day, nice day for ducks only." "We have been in swimming all day. We are waiting for dinner and watching the tide come in." "You all must just think how we look with our faces red and our arms brown but feeling fine." "Spending a few days here and having a very delightful trip."

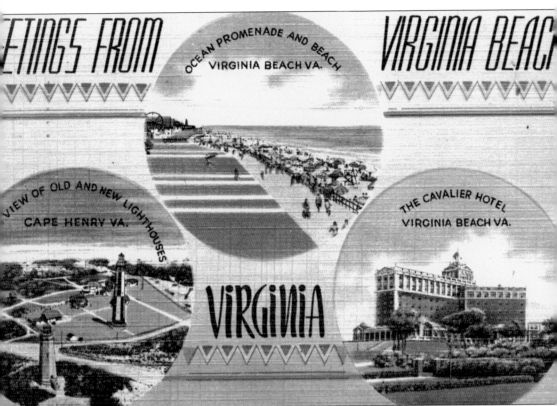

The publisher of this card, Southern Candy Co., took images from three other postcards and printed them on this one. This card was postmarked 1949, but these quotes come from cards sent at many different times: "Having a good time. Taking in all the sights." "This is a very beautiful place. Weather was fine today we've been swimming all day." "July 23, 1930, Dear Friend, Certainly am enjoying my trip and also some good bathing in the ocean. We are going to stay here several days and then go to Washington." "Tuesday, July 20, 1954, I am at 4H Camp at Virginia Beach. Plenty of girls here. I have got two or three in mind. I guess I'll see you in a week."

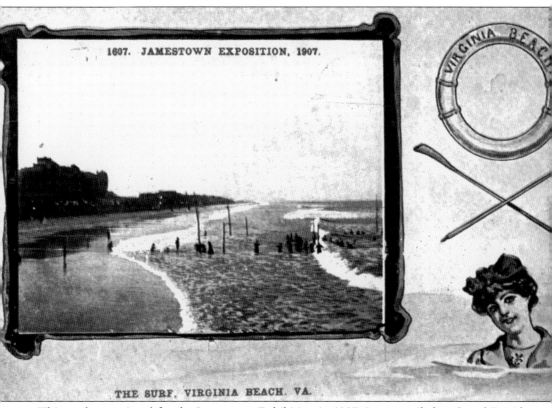

1607. JAMESTOWN EXPOSITION. 1907.

THE SURF. VIRGINIA BEACH. VA.

This card was printed for the Jamestown Exhibition in 1907. It was mailed to Grand Rapids, Michigan, that same year. The 300th anniversary of the Jamestown Settlement was a huge tourist attraction and filled hotels in all the surrounding cities. These comments record visits to Virginia Beach over the years. "Dear Mom and Dad, Here we are at Virginia Beach. Our room faces the ocean & we already went for a swim." "Hello everyone, The place is lovely, the weather beautiful, the water warm and nothing to do. It's a grand life." "It is wonderful here. However, we got too enthusiastic about the sun yesterday. Will have to take it easy today." "I'm having a grand time here. Bathing in the ocean is the main sport here. Sunday we take a boat to Washington."

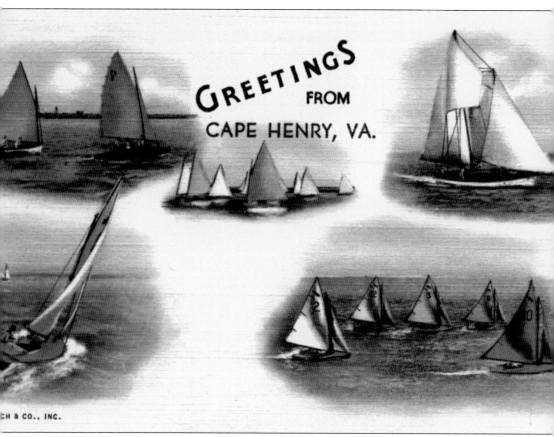

This is another "non specific" card where the town's name was added after publication. This was obviously a card for a sailing enthusiast and is quite beautiful in color with the pastel sails against light shades of blue. The comments following were talk about other ways to enjoy the summer at Virginia Beach: "We are spending the summer here. Wish you were here to fish with us." "The surf is awful rough. Too much for me." "Having a good time down here with the family." "Dear Sister, We are having a grand time even tho it has been raining since Wed. noon." "Am having a fine time down here, it sure is a beautiful place." "I went to an amusement park Sat. evening and had a lot of fun. Wish you were here, Bill."

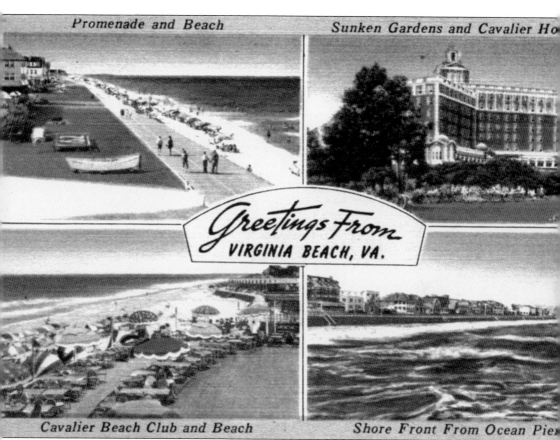

Promenade and Beach

Sunken Gardens and Cavalier Ho

Greetings From VIRGINIA BEACH, VA.

Cavalier Beach Club and Beach

Shore Front From Ocean Pier

Known as a multi-image card, this is actually four postcards combined into one. These quotes are also from several cards and are combined here to give a glimpse into how people expressed themselves over the years. "I thought you would like this P C." "July 17, 1912, We are all just having a dandy time. Went in this morning at 6:30 and the waves were great. Spent another bundle last night. Wish you could be with us." "I'm having a peach of a time. Obtained a pass to Tommy's base so we even eat together after he's off." "Dear Mom, Well, it's one windy afternoon. The Atlantic Ocean is beautiful. It's about 95 degrees. What a difference."

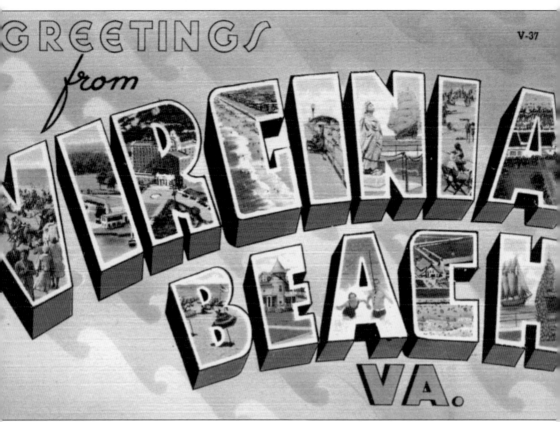

GREETINGS from VIRGINIA BEACH VA.

Very popular with postcard collectors, this is referred to as a "large letter greeting" card. Each letter in Virginia Beach contains an image from another postcard. Look closely and you will see several that are included in this book. The following comments are also taken from other cards in this volume: "You should be here, you would love the surf bathing. It is swell. We are having a good time. Hate to go home." "Am here for my vacation & having a fine time." "Dear Mother & Dad, This sure is a different beach from others. No concessions on boardwalk, instead on Main Street. Nice Place though and we have a real nice motel one block from the beach."

This is also a large letter greeting card, but the images on this card are not specific to any one place. "Cape Henry, VA." was added with a stamp. These quotes are from vacationers over the years. "Hello, Down here for a week. Having a swell time." "We are hearing a storm and the ocean is simply beautiful. Oct 8/07." "Plenty of water but no sun so I won't get that tan I planned on." "We're dunking ourselves in the brine. The blondes are beautiful here. Hurry!" "We are enjoying our stay here. Very hot, 93 in the shade." "Cape Henry, Aug. 2, 1907, Very nice and pleasant out here 16 miles out from Norfolk."

These two young ladies are professional models who posed for this card and the card on the next page (and probably many others). This is another card where the town name was added after the initial printing. The quotes following are from cards sent over several years: "I have been to the amusement park so much at the beach that I am really getting tired of it." "The girls are going for a swim now. I'm going sun bathing and see that they don't get too rough." "Wish we could spend some time together at this place." "Hi Gals, Boy this is the life." "Dear Rolden, This place is a fizzle and I doubt if we will stick it out for a full week. Love, Clara." "We're beginning to look like beets from the sun & talk like the navy from seeing so many sailors."

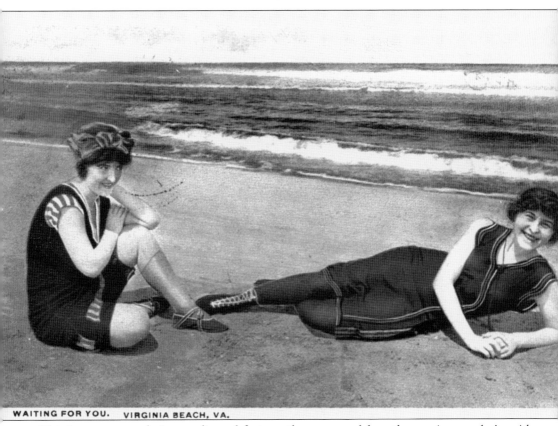

WAITING FOR YOU. **VIRGINIA BEACH, VA.**

This image was made in a studio and features the same models as the previous card. As with that card, "Virginia Beach, VA." was added to the generic greeting. Here are more comments from other cards: "Hi Neighbors, The water is nice here, but we know we like the weather much better at Cape Cod." "Dear Amilia, Here I am a long way from home but having fine weather and a lovely time. Home soon." "Come on in, the water is fine." "My first trip to an ocean resort. So far it's great. Went to a dance for Middies at Little Creek, Va. last night and got to bed at 4am. Love to all, Ruth."

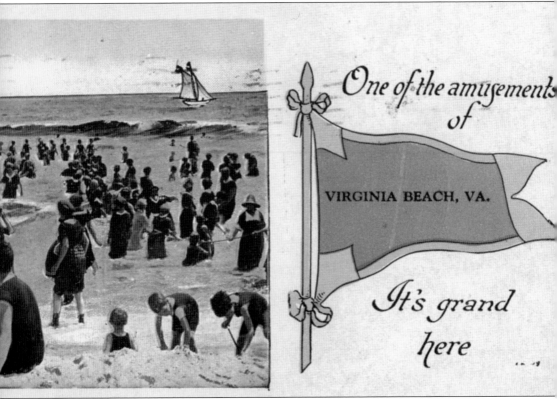

One of the amusements of

VIRGINIA BEACH, VA.

It's grand here

Here is a card published by Pennant Bathing Surfs and Design. This same card can be found as a souvenir of Newport Beach, Ocean View Beach, and Buckroe Beach. This card was mailed in 1932. The comments here are from various cards over several years. "Having a grand time. Wish you were here to go bathing." "April 20th, 1933, Thursday. We were at Virginia Beach but it was cold we couldn't stay out. The waves were so high also from the wind." "We're having simply a wonderful time. Weather just perfect. Gaining weight too." "Decided I'd spend my vacation way down here. We have had a swell time so far and much better weather than we had in Atlantic City."

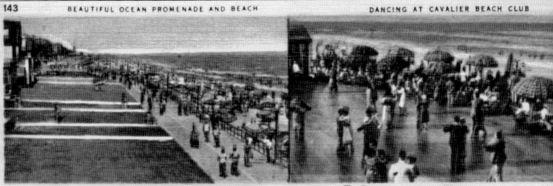

BEAUTIFUL OCEAN PROMENADE AND BEACH DANCING AT CAVALIER BEACH CLUB

FOUR REASONS WHY YOU SHOULD COME TO Virginia Beach Va

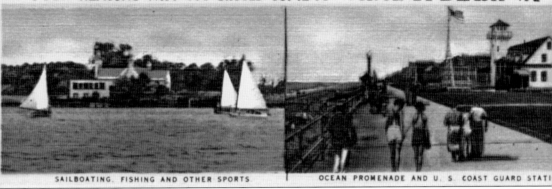

SAILBOATING. FISHING AND OTHER SPORTS OCEAN PROMENADE AND U. S. COAST GUARD STATI

This card was sent by a sailor to his parents in Buffalo, New York, in 1943. The publisher used a common template but customized the card for Virginia Beach. The comments come from other cards. "Here is an idea how things are around here." "Hello there, I just got in for the night from the Atlantic Ocean. Have seen plenty of water today and some to spare." "This is a nice place. Better come here on your vacation. Good place to get a sun tan and meet lots of southern belles." "Two swims a day, three remarkable appetites a day. You will hardly know me."

Me and the Ocean
Virginia Beach, Va.

The chamber of commerce ordered this generic card from a publisher and had "Virginia Beach, Va." added. Below are several sentiments about Virginia Beach and the ocean: "Dear Mother, Here is a nice view of the waves. Some times they are bigger than at other times. Sometimes the waves are very small and it is referred to as smooth ocean. The ocean is smooth today. When the tide comes in the ocean waves come up on the beach and the water reaches the wall. I have been in the ocean for 3 or 4 weeks."